1987

AUGUST SANDER

AUGUST SANDER

PHOTOGRAPHS OF AN EPOCH 1904-1959

Man of the Twentieth Century
Rhineland Landscapes, Nature Studies,
Architectural and Industrial Photographs,
Images of Sardinia

Preface by Beaumont Newhall

Historical Commentary by Robert Kramer

Accompanied by excerpts from the writings of
August Sander and his contemporaries

An Aperture Monograph

To the Memory of Anna Sander

August Sander: Photographs of an Epoch is an exhibition presented by the Philadelphia Museum of Art from March 1 to April 27, 1980, to travel to major institutions throughout the United States.

August Sander: Photographs of an Epoch, an Aperture monograph, is published as a catalogue for the exhibition, as a book for general distribution, and as a special issue of the periodical. The exhibition is coordinated by Martha Chahroudi and directed by Michael E. Hoffman.

The organizers of the exhibition of August Sander's work and the editors of this publication wish to express their gratitude to the photographer's family. Gunther Sander, August Sander's son, provided many of the photographs. Sigrid Biow, Sander's daughter, gave generously of her time, shared numerous experiences and perceptions about her father, and lent photographs from her collection. Gerd and Christine Sander, August Sander's grandson and his wife, who direct the Sander Gallery in Washington, D.C., provided photographs, background information, support, and guidance. Without their assistance this publication could not have been accomplished.

Invaluable editorial assistance was provided by R. H. Cravens. The manuscript was checked at every stage by Eleanore W. Karsten. Translations of August Sander's writings on pages 40, 82-83, 94, and 104 are by Robert Kramer.

Aperture acknowledges the generous loan of August Sander prints from the Deutsche Gesellschaft für Photographie, E.V. (German Photographic Society), in Cologne and the cooperation of the president, Dr. Hans Friderichs and the members of the board of the German Photographic Society: L. Fritz Gruber, Hans-Gerhard Kindermann, Karl Steinorth, Hans Ulrich, O. Michael Artus, Heinz C. M. Bindseil, Friedrich Granzer, F. C. Gundlach, Gottfried Jäger, Rolf H. Krauss, Bernd Lohse, John van Nes Ziegler, Heinz Orbach, Walther H. Schmitt, Gert Koshofer, Gerhard Schröder, Bruno Uhl, Theo Burauen, Wolfgang Eichler, Heinz Hajek-Halke, Fritz Kempe, Alfred Miller, Kinji Moryama, Josef Schuwerack, and Hanns J. Wendel, Walter Boje.

Additional prints were lent by the Philadelphia Museum of Art; Phyllis Lambert (on loan to the Canadian Centre for Architecture); Thomas Halsted, Halsted Gallery, Birmingham, Michigan; and Hans Namuth.

The contributions of the following individuals are also appreciated: Karen Coape-Arnold; Almut Fitzgerald, Goethe House, New York City; Karen Greenberg, Sander Gallery, Washington, D.C.; Richard Henderson; Linda Neaman; Richard Pare; Florence Tarlow; Barry Winiker; Anne Zaccagnino; and Harda Zerbst.

CONTENTS

PREFACE

August Sander was one of the leading photographers in Germany during the first half of the Twentieth Century. Trained as a professional portraitist, he developed a personal style characterized by startlingly direct photographs of German people of all classes and all callings, to produce a body of work unparalleled in the history of photography.

Our view of photography in the 1920s — when Sander's first important book, *Face of Our Time,* appeared — is based largely on the experimental photographs of the Bauhaus group, whose chief spokesman was László Moholy-Nagy. To them, the camera was a tool for the exploration of what they called the "New Vision," and the popularity of their exciting new approach tended to eclipse the work of others. They looked at nature and the environment not with the eye of the realist but that of the abstract artist. They sought shapes and forms rather than body and texture. The world provided them with "light modulators," to use the phrase coined by Moholy-Nagy. They pointed the camera up, delighting in the utter distortion of conventional perspective. They looked down from high places at city streets, parks, and squares, and caught the abstract patterns. They collected aerial photographs. They presented negatives as the final product, and pointed out that the reversal of black and white increased the abstract value of the image. They looked for images beyond the power of the naked eye to see: X-rays of the hidden skeletons of men and animals, photomicrographs of living cells, astronomical photographs of unseen stars. They produced purely abstract photograms by exposing to light photographic paper with objects placed on it.

A vast exhibition, "Film und Foto," emphasizing the work of the most extreme practitioners, was held by the prestigious Deutsche Werkbund in Stuttgart in 1929. Books of their photographs were published: *Photo-Eye (Foto-Auge),* edited by Franz Roh and Jan Tschichold; *Here Comes the New Photographer,* with a didactic text by Werner Graeff. The New Vision was seen in motion pictures in the films of Karl Freund for *Variety* and *The Last Laugh,* in Eisenstein's *Potemkin* and Pudovkin's *Mother,* and especially in Dziga Bertov's *Man with a Movie Camera,* all of which were shown at the Stuttgart exhibition. It is not surprising that Sander's photography was not included in that influential exhibition. The New Vision was essentially nonobjective in contrast to the strong reality of his photographs.

Sander's style was based on three separate yet interrelated aspects of photography in the period 1900-1930: the development of "at home" portraiture by professionals; the abandonment of romantic pictorialism in favor of realism; and the rapid growth of the documentary approach by filmmakers, photographers, and the editors of the illustrated press.

Until the early Twentieth Century almost all photographic portraits were made in studios equipped with enormous skylights. Poses were stilted and the environment was highly artificial, with painted backgrounds, rich draperies, sleazy furniture, and artificial flowers stuck into ornate plaster-of-paris vases. In the days of the wet-plate collodion process, the negative materials had to be sensitized immediately before exposure. Camera and darkroom had to be close to each other. Work outside the studio was difficult, for it meant toting

along not only a bulky camera and tripod, but processing equipment and chemicals. The advent of gelatin silver bromide emulsion in the late 1880s changed everything. Readymade plates that could be exposed long after purchase and developed long after exposure became available. At-home photography became possible, and soon German photographers excelled at it.

Rudolf Dührkoop (1840-1918), a specialist in the at-home approach, lectured about it to American professional photographers as early as 1904. He emphasized that sitters found such portraits charming because they were authentic. A person could tell friends, he said, that "this portrait was taken in the house of my betrothed, my parents, or in some spot forever dear to me, and with which certain dear associations are connected."[1] Unlike most studios, Dührkoop's had high side windows instead of the skylight considered essential for photographers in those days before electric light was common. Dührkoop also introduced American photographers to the charms of outdoor portraiture, then barely conceivable even to a professional. "Compared with the frequently stereotyped uniformity of the studio light," Dührkoop said, "the great diversity of open air and interior exposures, with their continually varying scenery, is immensely more interesting, and every thinking photographer ought to endeavor to master and develop this side of photography and to turn this delightful diversity to account also in a business way."[2]

When Sander had his first large one-man show in Linz, Austria, in 1906, pictorial photography was at its height, and its leaders were actively seeking recognition of photography as a fine art. Most were in England and America, where two highly influential societies were promoting exhibitions of photographs chosen solely for their aesthetic merit: the Linked Ring in London and the Photo-Secession in New York. Germany was not far behind, with annual exhibitions in the Hamburg Kunsthalle, organized by Ernst Juhl and held under the enthusiastic sponsorship of the museum's director, Alfred Lichtwark. The Kunsthalle was the first art museum in the world to hold regular photographic exhibitions, and it was Lichtwark's belief as early as 1894 that photography's stultification, particularly in professional portraiture, could be ameliorated by showing the informal work of the more venturesome amateurs.

The style of the pictorial photographers of the 1900s was painterly. In their desire to win acceptance of photography as art, they tried for broad effects by using a soft focus and expensive retouching. They often favored pigment processes for printing. Rough-textured paper was made light sensitive not with silver salts in emulsion but with watercolor pigment mixed with gum arabic and potassium bichromate. Potassium dichromate (the modern name for potassium bichromate) causes gum arabic to become insoluble in water when exposed to light. In the negative the highlights are dense, or relatively dark, while the shadows are relatively clear. When gum paper is exposed to sunlight beneath the negative, the highlights remain relatively soluble, while the shadows become insoluble. "Development" consists merely of washing the exposed paper in warm water. By increasing water temperature and vigorously scrubbing with a stiff brush the photographer can

change any portion of the image at will. The paper can then be recoated with bichromated pigment and exposed again beneath the negative to produce two-color or even three-color prints.

Despite the fact that Sander was a master of the gum print, like so many of his contemporaries — Alfred Stieglitz, Edward Steichen, Edward Weston, to name the most prominent in America — he abandoned the process completely in his mature years in favor of the silver halide papers widely used in commercial photography. These papers have a smooth surface capable of rendering every detail recorded by the negative of a sharply focused image. "Straight photography," as it was called, came close to being a cult with avant garde photographers. Alfred Stieglitz wrote in 1913: "Photographers must learn not to be ashamed to have their photographs look like photographs. A smudge in 'gum' has less value from an aesthetic point of view than an ordinary pin type."[3] Sander also deplored the manipulation of the photographic image. For a radio broadcast in 1931 he said:

The essence of all photography is of a documentary nature, but it can be uprooted by manual treatment If we compare, we will ascertain that a photograph produced by the pure configuration of light and with the aid of chemicals is far more aesthetic than one muddled by artificial manipulation.[4]

Sander's lifetime project, "Man of the Twentieth Century," was in every sense documentary — though the word was seldom applied to photography when he first conceived of the project. The value of the photograph as a document is implicit in its physical nature, a characteristic that had been recognized since the earliest days of photography. But the use of the term "documentary" to describe photographs taken specifically to convey information of a sociological nature began in the 1920s, particularly in motion-picture criticism. Films of fact featuring real people and shot on location, as opposed to fictional films with actors playing their roles in a studio, became widely popular, particularly in Germany and England. Walther Ruttmann's *Berlin, Symphony of a Great City* (1927) showed the real city from dawn to dusk with real people going about their everyday affairs. John Grierson's *Drifters* (1929), a story about herring fishery, was filmed with real fishermen in the North Sea.

This widespread interest in the factual affected not only photography and film but painting also. At the same time that the appreciation of abstract art was growing in Germany in the 1920s, a movement in painting called the *neue Sachlichkeit* was emerging. Usually translated as the "New Objectivity," it was based not so much on nonsubjective vision as on a concern with reality, with "thingness" ("*Sache*" means "thing"). The chief proponent of this realism, often extreme to the point of brutality, was the painter Otto Dix, who was a friend of Sander's.

It is remarkable that a man so interested in people did not become politically involved. Sander photographed Communists and Social Democrats with the same objectivity with which he observed the rich and the poor, the professional and the laborer, the intellectual and the idiot. This is all the more remarkable since it was during the Weimar period with all its

upheavals that Sander was most active in his great documentation of the German people. For the camera was then being widely used as a political tool, particularly by the Communists in their propaganda.

Sander's utterly nonpolitical stance in his photography makes the confiscation by the Nazis of the book *Face of Our Time*, the first in the projected series "Man of the Twentieth Century," puzzling until we realize that Sander's subjects include all types, many of which were in disfavor. The opposition to Sander's photographs of people led him to turn his camera on the landscape and industrial architecture — fields certainly nonpolitical and seemingly depersonalized. But in his landscapes August Sander shows by the evidence revealed in them not merely the natural scene but the result of the labors of the very people he had photographed in fact, the very environment of Germany and the German people.

—BEAUMONT NEWHALL

1. "Rudolf Dührkoop on Portrait Photography," *British Journal of Photography* (Sept. 22, 1911), p. 720.

2. Ibid., p. 721.

3 Quoted in *Photo-Miniature*, No. 124 (March 1913), p. 220.

4. August Sander, *The Nature and Development of Photography*, Lecture 3 (Cologne: West-German Radio, 1931).

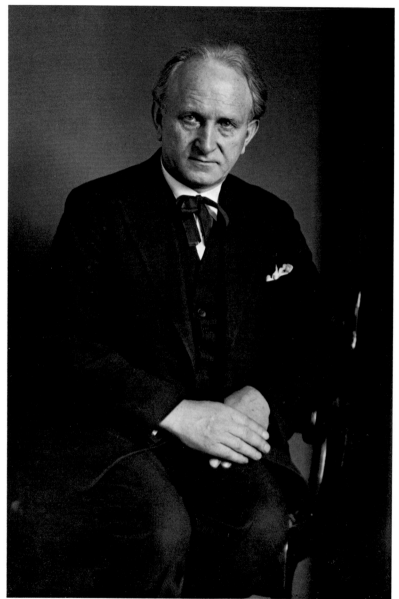

August Sander 1937

In the summer of 1934, the Reich Chamber of Visual Arts ordered that the publisher's printing blocks for a remarkable, slim volume of photographs entitled *Antlitz der Zeit (Face of Our Time)* be destroyed and all available copies of the book be seized. News of the suppression was conveyed immediately by the publisher, Kurt Wolff, to the photographer, August Sander. When Sander received the brief note in his comfortable, antique-filled Cologne home, he was enraged — and helpless. The sixty photographs contained in the book, first published in 1929, represented a small fraction of a work that had consumed him for nearly a quarter of a century, and the Nazi prohibition effectively brought that work to a halt.

Sander's was a grand ambition: he sought to document the German people, the individual types as shaped by their traditions, their lot in life, their labors, their social class, and their generic temperaments. He had offered up the first glimpse of this work several years earlier with the following explanation:

The book before you, Face of Our Time, *is a popular edition in the best sense of the word. It provides a glimpse of my work toward the forthcoming great publication* Man of the Twentieth Century. *I began this work in 1910 and have been constantly active with its development. It is to contain a still more finely nuanced arrangement than the book before you. The principle of organization in the large work is the following (I begin again with the peasant): as the first portfolio, the* Stammappe *[original portfolio] is arranged according to the following points of view:*
Plate I, The Earthbound Man
Plate II, The Philosopher
Plate III, The Revolutionary
Plate IV, The Wise Man
Plates V-VIII, The Woman (in the same
 succession as I-IV)
Plate IX, The Woman of Advanced Intellect
Plates X-XI, Two Couples, Self-Control and Harmony
Plate XII, The Family in Generations
The whole work is divided into seven groups, corresponding to present-day society and comes to a total of about forty-five portfolios with twelve photographs in each. It proceeds from the earthbound man to the highest peak of civilization, and downward according to the most subtle classifications to the idiot.[1]

The photographs in *Face of Our Time* were arranged by Sander in a sociological arc beginning with peasants; "ascending" through small-town people, workers, bourgeois, students, politicians, revolutionaries, clergy, professional people, industrialists, artists, writers, and musicians; and then "descending" through bar waiter and cleaning woman to the final tragic image of the unemployed worker in the big city.

Sander had every right to feel that he was both justified in his ambition — and that he was embarked on the right course. Critics throughout Europe greeted the book not just favorably, but in some cases with outright delight. Thomas Mann, who received the Nobel Prize that year, wrote to the publisher, "I have looked through *Face of Our Time* with great interest and pleasure, and I congratulate you on its publication. This collection of precise and unpretentious photographs is a treasure-trove for lovers of physiognomy and an outstanding opportunity for the study of human types as stamped by profession and social class."[2]

A reviewer for a Budapest periodical, the *Pester Lloyd,* may have surpassed Mann in recognizing the significance of Sander's achievement:

The sixty photographs in this excellent picture book entitled Face of Our Time *give, in the form of photographs, sociological and biological representations of whole types of society. They possess the eloquence of complete volumes of serious and satirical descriptions. They are contributions to a development of man as a member of society; in them we encounter originals, who with the greatest impressiveness represent types; we encounter well-known acquaintances, whom we have never seen before and who, nevertheless, pass by us every day with their striking characteristics. An amusing book, an art book, created by the greatest artist of all — real life.*[3]

The ban was a severe blow to Sander, who was nearly sixty years old. On the surface, at least, he was the ideal German citizen. He was successful in business as well as in his artistic ventures, the recipient of numerous awards and medals. He was a Social Democrat, and he had a devoted wife and three talented children. After the ban, Nazi proscription frightened away potential customers. Worse, for Sander, he could not continue work on his grand project because of political pressure.

There are a number of possible reasons why Sander incurred Nazi displeasure. Flushed with power, Third Reich functionaries often did not bother with explanations of their edicts. Sander's elder son, Erich, was a known foe of the regime, and his activities may have helped draw attention to his father and his work. The introduction to *Face of Our Time* was written by a celebrated literary figure, Alfred Döblin, a Berlin psychiatrist. Döblin's novel, *Berlin, Alexanderplatz,* published in 1929, was such an artistic and popular success that it passed through forty-five editions in two years. Wolff had solicited Döblin's contribution to add both prestige and sales value to the book. Though a Roman Catholic convert, Döblin was of Jewish extraction, which was enough to damn his name in Nazi Germany. Sander's selection of subjects, too, would have jarred aestheticians of the Third Reich. Jews, Communists, revolutionaries, Gyp-

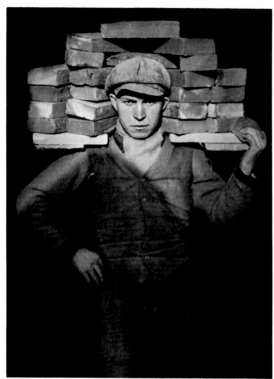

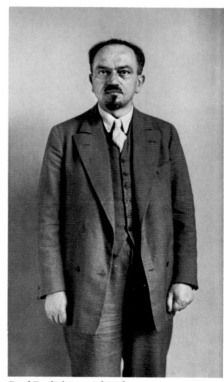

Bricklayer's mate, from *Face of Our Time*,
Cologne 1929

Paul Frolich, socialist, from *Face of
Our Time*, Frankfurt 1928

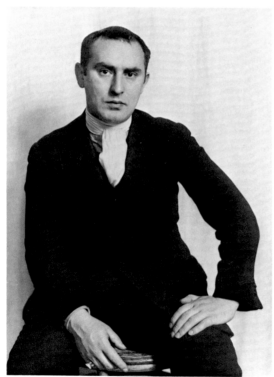

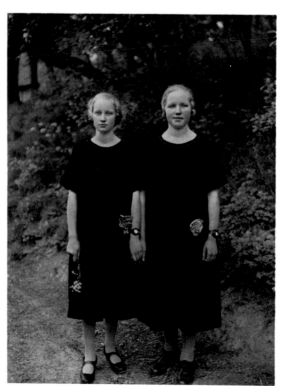

Painter Jankel Adler, from *Face of Our Time*,
Cologne 1928

Peasant girls, from *Face of Our Time*,
Westerwald 1928

sies, and Negroes — all anathema to those fashioning an ideology of racial purity — were among those who had paused before Sander's lens.

There is another reason why Sander may in fact have been viewed by some astute Nazi ideologue as a serious threat to the regime. Both the Nazi mythmakers and the Cologne photographer were in a way trying to get at the same thing. Both were looking for the influences shaping the German people. To the question, "What is German in German art?" one Nazi theoretician, Kurt Karl Eberlein, responded:

The homeland, the landscape, the living space, the language community are embodied in the family that roams and grows beyond its borders. In it lives the child with mores and customs, the dialect of play, of celebration. In it live the song, the fairy tale, the proverb, native costume and furniture and utensils. In it lie the ultimate energies of primordial folk art.[4]

The Nazi emphasis lay in *Stämme*, the Germanic tribes with their values rooted deeply in the earth. From this derived the image of the mystical being whose natural heritage was his superiority. In painting, film, sculpture, and photography, the theme was unvaried — heroic young Aryan warriors, magnificently shouldered, with determined, somewhat vacant eyes; cheerful, beautiful young women, images of health, fertility, and sexual pleasure for the warriors; peasants who were strong, uncorrupted, close to the earth from which they had sprung. The demand placed upon the German artist, expressed in Adolf Dresler's work, *German Art and Degenerate Art* (Munich, 1938) was to reproduce "the face of the leader — heroism, loyalty, comradeship — beauty of the homeland — human beauty."[5]

Seldom was anything of the kind to be found in Sander's portraits. Peasant, government official, student, laborer, and all the others presented themselves as they existed, in their own milieu. Usually they were photographed full length, their faces looking with all seriousness directly at the viewer. Sander's genius was to let his subjects appear as they were, to let each face relate its own history. Many of these faces were etched with weariness, hardship, sorrow, reserve, and acceptance. Occasionally, Sander's subjects bordered on the grotesque. There were few if any heroes here, but these were the German people — at least a sampling of them — who occupied the niches of society at the time.

That Sander was on a collision course with the Nazi myth mechanics was even more inevitable because both were drawing upon an old, compelling intellectual tradition — the concept of physiognomy. In his view, physiognomy revealed that an individual face portrayed not just the person's inner character, but also his trade, economic experience, and social position. Sander was in deadly earnest, and thoroughly confident that he could document the human being of the Twentieth Century, and that what he called "the universal language of photography" would make that record evident to any sensitive viewer. The Nazis, too, believed in physiognomy, but approached it in exactly the opposite way. They had created the mask of the Aryan hero and his female consort, and they struggled to fit these visages upon the "faces" of Germany. The trouble was that anyone could look around and see Sander's faces everywhere: Nazi physiognomy was evident only in propaganda films and posters.

Banned, declared an antisocial parasite, Sander was forced to abandon his project, and so he turned to landscape photography. In the mad perversity of the Third Reich, this

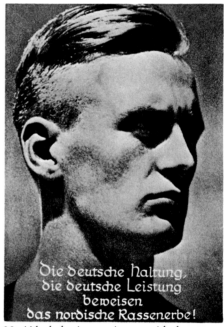

Nazi ideal physiognomic type with slogan: "German bearing, German achievement prove the Nordic racial inheritance"

compulsive realist found himself ranked with the "degenerates" whom Hitler excoriated in 1937 at the opening of the German House of Art in Munich:

Cubism, Dadaism, Futurism, Impressionism, etc., have nothing to do with our German people. For all of these concepts are simply the affected stammer of people to whom God has denied the grace of a true artistic talent, and instead has bestowed on them the gifts of loquacity or downright deception. An art that cannot count on the most joyful and heartfelt assent of the healthy, broad mass of the people, but that is supported by only small cliques — partly interested and partly blasé — such an art is intolerable. It attempts to confuse the healthy, sure, instinctive feeling of a people instead of joyfully supporting it.[6]

Those banned and held up for public scorn ultimately included many of the greatest artists of this century, including painters such as Wassily Kandinsky, Paul Klee, and George Grosz, along with Sander's politically and artisti-

cally progressive friends, Gottfried Brockmann, Willi Bongard, and Jankel Adler. Expressionist architect Otto Poelzig joined such illustrious colleagues as Walther Gropius and Mies van der Rohe on the Nazi hate list, as did composer Paul Hindemith. By the thousands, artists and intellectuals fled Nazi Germany, but Sander remained behind. Further crushing blows were to follow. The Nazis killed one of his children, and Sander and his wife, Anna, were publicly harassed for consorting with Jews and other undesirables. His home was relentlessly searched, the archives rifled, and many pictures confiscated. The war resulted in the destruction of a great portion of his life's work. Yet Sander and his wife survived the Third Reich, and lived to see his work gain an international audience long after his suppressors were destroyed.

August Sander's birthplace was Herdorf, a small village in western Germany about 150 miles east of Cologne. It is located in a beautiful, heavily wooded valley where the Sottersbach flows into the Sieg River. He was born on November 17, 1876, the son of August, a mining carpenter, and his wife, Rosette, a woman whose peasant roots in the valley traced back for centuries. The Siegerland offers a wonderfully varied topography of mountain, valley, and river, and the forests are cleared for small farm plots. Vast ore deposits spawned large-scale and also smaller, family-owned mines, which usually were rented out to bring some extra income.

In later life, Sander — who was among other things a charming memoirist — offered numerous glimpses of his early childhood. In one, he described his homeland:

The valley of the Sottersbach ... is narrow and lovely, enclosed by richly wooded mountains, and the brook meanders in many twists and turns. With every season the splendid landscape changes its colors. The fish sport in the brook, and the trout especially play their lively games. . . . The Sottersbach provides them with excellent living conditions, with its banks overgrown with bushes and reeds, and its many hiding places. Here, too, the songbirds find favorable living conditions, and at an early age I learned to recognize the different species. . . . There were new impressions daily, and every day brought new experiences.[7]

Like others in the area, Sander's family owned a small farm, and the nearby forests also offered necessities. With his mother, who was steeped in folk medicine and local myths, Sander went on frequent foraging expeditions, one of which he recalled:

As soon as the sun began to melt the snow, my mother took me along to look for wild plants. It was not always pleasant; our fingers often froze wretchedly, and when we went after stinging nettles, I began to grumble. My mother set me right

by saying: "We eat, my boy, so that we don't die of hunger, but it depends on what we eat. There is no plant that can keep us from death, but there are many that can help prolong our life and drive away sickness."[8]

Dominating life in the valley was the San Fernando mine. The Siegerlanders relation to their mines has nothing in common with the hellish picture provided by British authors of the miner's lot in England and Wales. Sander's recollections give an almost storybook quality to the mine.

On the opposite slope of the mountain, to our great joy, a little locomotive from the 1870s groaned and panted in all possible and impossible tones. Several times a day it pushed heavily laden coal cars up the valley to a mine, and carried down iron and iron ore that the miners at the upper end of the valley had brought to the surface.[9]

From 1882 through 1888, August attended the village school, but the Sander family, for all of its careful, frugal ways, had nine children to support, and the next year he went into the mine to add badly needed extra income. It was not an unusual situation in the village: many of his classmates did the same. For most, the mine was the one sure prospect for the future.

If Sander inherited his love for nature from his mother, it was his father who first inspired his interest in art. Describing a winter evening with the family around the kitchen stove, he later wrote:

Our father, who always took part in our activities, enjoyed drawing very much. The cats, who liked to lie on top of the stove, were his models. Sometimes one of my sisters would pinch a cat to make it jump with a hiss from the stove to the floor. Very beautiful drawings resulted, and I enjoyed them very much. I tried to do the same myself, and after a while, I became quite successful and continued to draw for a long time afterward.[10]

About this time Sander decided to become a painter. This decision was somewhat qualified, however. From his parents Sander had acquired an earthy philosophy, one that he later impressed upon his own children. Summed up, it was: duty first, pleasure later. A man's first task was to pay his dues for living, to meet all necessary obligations, and then he might pursue the things that gave him the most joy. In Sander's view, one did not eliminate the joyful — far from it — one set it as a second priority, even a reward. Though Sander had decided upon painting as a career, his first responsibility was to learn the skills of the miner, to work at the trade, and to contribute to the family.

One day at the mine Sander had a chance encounter that redirected the course of his life:

Once at the pit heap, where the iron is separated from the iron ore, I saw a man approaching with a big camera, about 30 × 40 cm., and a tripod, which he set down outside the

office. A short time later, the foreman called me to show the man the way to the high hill. I got an ax and a hatchet from my parents, because our house was close to the path leading to the hill. It was a beautiful summer day. First we had to remove the shrubs so that we could have an unobstructed view of the town. Then the camera was set up. This was the first time that I had ever seen one, and I was so enthusiastic when I looked into the viewer that the moment has never left my memory. Everything was moving, even the clouds in the sky, and I saw for the first time how one can hold fast the landscape with a camera.[11]

Young Sander was unusually silent that night. Soon he announced that he had changed his mind about becoming a painter, that he intended to become a photographer. He also mentioned that he must acquire a camera. His father was doubtful: it was an expensive acquisition and there was no spare money. If there was a single quality that marked the entire Sander clan, however, it was perseverance.

The young man saved his money, pfennig by pfennig, and his father also contributed small loans to the project. In the meantime, the sympathetic landscape photographer sent the youth a book so that he could begin learning the technical lore of the craft. The money accumulated with painful

August Sander (at easel) and brother Karl, Linz 1903

slowness until Sander's maternal uncle, Daniel Jung, the director of a prosperous Hungarian gold mine, learned of the problem. He advanced the youth the rest of the funds necessary to get started. A 13 × 18-cm. camera—the smallest then available — was purchased, along with the other necessary equipment and materials. Sander's father helped him build a small hut adjacent to the barn for a darkroom. Well water was nearby, and an oil lamp was equipped with a red-glass cylinder to provide light for developing.

Most great photographers are self-taught. But the youth ran into particular difficulties trying to pick his way through the elaborate technical explanations, replete with Latin terms, in his sole photography textbook. He sought out the local physician, the only person in the village with enough scientific training to help him wade through the abstruse terminology.

There are two accounts of Sander's first photograph. As the photographer later recounted:

I put in the plates and began my first photographic tour, to a hilly part of the village from which I photographed the landscape where the mines were. In the evening I developed the plate, but when I finished, a second village was reflected in the clouds. At first I thought I had made a double exposure and was very depressed about the picture. When the plate was dry, I went with it to our village physician and told him what had happened. The doctor said it was not a double exposure but a Fata Morgana—a mirage, a reflection in the air. This was my very first photograph.[12]

Sander's son Gunther remembers hearing a different version. Arrangements had been made for a formal sitting with the family next door. One brilliantly sunny morning, they arrived at the Sander house, dressed in their Sunday best. Sander composed the group, then snapped his first photograph. That night, the freshly developed negative seemed fine. When he set out to print the picture, however, he had mistakenly decided that the ready-made albumen paper had to be protected from strong light at all times, although it actually required several hours of sun to produce an image. He started printing in dim daylight, and when no image was forthcoming, he went off to his chores, bitterly disappointed, leaving behind the printing frame. When he returned later, several hours of light had done the job: he found a perfectly printed photograph.

His elation was not echoed by his subjects. They found the unretouched, painfully accurate picture almost offensive; the children, it seemed to them, had lost their beauty in Sander's photograph. Others were equally displeased with the youth's no-nonsense pictures, but he was photographing them at no charge and there was no shortage of subjects. Soon, young men preparing to emigrate to America also sought him out, to leave portraits of themselves with their families. When the initial supplies ran out, Sander began charging modest fees, and with the proceeds paid back the money his father and uncle had lent him to start the project.

At twenty, Sander was called up for compulsory military service and stationed at the garrison in Trier, a small city on the Mosel River. Wherever soldiers gathered, there were always photographers, and one day the new recruit discovered one of these portraitists outside his barracks virtually overwhelmed with commissions. Sander offered to help,

and the photographer readily assented. Pleased with the young man's skills, he soon enlisted most of Sander's free time at the Jung studio, helping churn out souvenir pictures for the garrison—and so provided Sander with his first taste of apprenticeship.

When his military service ended in 1899, Sander informed his parents that he had decided to remain for a while in Trier to continue his photographic studies. A more compelling reason was a small, energetic young brunette, a milliner's assistant, named Anna Seitenmacher. They first met while Sander was photographing, and he was soon in love. He wanted to propose, but he did not yet have the professional expertise or the credentials that would enable him to earn a satisfactory living. Her father, a clerk of the court in Trier, may have raised particular objections to a young man who, as yet, had no visible prospects. Sander set out, like a traditional journeyman, to become a master of his craft.

His apprenticeships took him to Hagen, Magdeburg, Halle, Dresden, and Berlin. In the capital, armed with an excellent testimonial from his Trier colleague, he was fortunate to land a position with the distinguished firm of Franz Kullerich. As well as doing studio portraits, Kullerich was highly regarded as a specialist in architectural and industrial photography. The experience Sander gained in Berlin later enabled him to compete successfully for commissions from architects, builders, and manufacturers. The association with Kullerich also helped crystallize his own inclination for meticulous order, the compulsive precision that characterized Sander's working method.

To round out his training, Sander also enrolled — again with help from his Uncle Daniel — in the Dresden Academy of Art. All studio photographers of the day were expected to double as portrait painters. Sander became a competent painter in oils and an accomplished, if not brilliant, landscape artist.

Now fully in possession of the skills of his craft, Sander confidently returned to Trier and asked for Anna's hand in marriage. He had just been hired as director of a photographic studio in Linz, Austria, and his prospects were excellent. Anna accepted, and the engagement period was set for one year. Sander went off to Linz alone, and a year later, in 1902, he and Anna were married in Trier.

The only event to mar this period was the first bitter foretaste of how it feels to lose negatives. In Herdorf, Sander's brother-in-law had been cleaning around the barn and hut. Without knowing what they were, he threw out all of Sander's negatives, except for a few of his earliest attempts. And so Sander lost at the outset a cherished part of his personal collection.

The young couple were nonetheless happy in their new home. Anna Sander has been called the "perfect artist's wife." She was young, resourceful, and possessed of an en-

ergy every bit as extraordinary as her husband's. She soon acquired a thorough capability in all aspects of studio operations from picture taking and darkroom techniques to the handling of bills and payments. On December 22, 1903, Anna gave birth to their first child, Erich.

Sander's abilities were soon recognized by the Linz community. He was at that period — and from any modern perspective — the complete photographer, and a shrewd client pleaser. In his training he had mastered all the painterly effects in vogue at the time, including the Impressionist-inspired techniques of using out-of-focus, uncorrected, or pinhole lenses to destroy unflattering details and outlines. Use of the gum bichromate process further allowed photographers to suppress detail, emphasize tonal massing of light

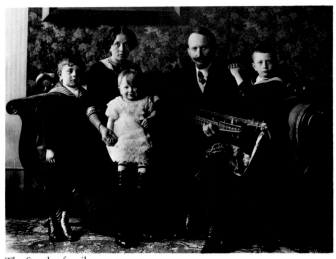

The Sander family c. 1913

and shade, and even to simulate the surface texture of brush, charcoal, or pastel. Years later, Sander called turn-of-the-century photography the "period of decline," and offered this satirical description of a typical practitioner:

For his everyday pictures, he used balustrades and movable sets as scenery, and painted backgrounds representing Italian landscapes and royal palaces; he attained the desired Rembrandt lighting with the help of mirrors. He transformed a kitchen maid into an elegant lady and a simple soldier into a general. The rest was taken care of by smooth retouchings, which removed every wrinkle from the face without leaving a trace.[13]

Sander avowed that such work was only catering to the vanity and the vulgar taste of the public. His own preference was for the straightforward, naturalistic study. He was not above giving the public what they wanted, however, and some of the earliest awards and critical acclaim he received were for his "art" photographs. Also, he was quite capable of eschewing the camera altogether and setting up an easel to render an oil portrait of the subject — if that was what was wanted.

Independent and ambitious, Sander persuaded the Linz studio owner, Helmut Gruber, to sell out for what was then a hefty sum — 20,000 crowns. Business was not quite good enough to support the heavy payments, and soon Sander

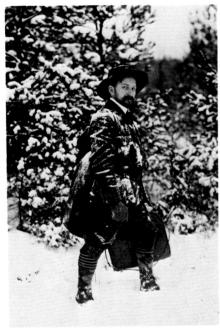

Sander on his way to the Westerwald 1911

was forced to take on a partner. Franz Stukenberg joined the photographer, and the studio was renamed Sander and Stukenberg. Fortunately, business grew and Sander — who was quite demanding and often difficult — was able to buy out the partner, with whom he had been having frequent quarrels. In 1904, Sander was once again his own master, sole proprietor of the business now named August Sander, Studio for Pictorial Arts of Photography and Painting.

In these early years he began submitting work to exhibitions and competitions, and from the beginning it was well received by critics, and generally by the public as well. In 1903, he won a state medal at a competition in Linz, followed by a gold medal in Wels in 1904. That same year, his success with some of the earliest three-color processes earned him a first prize — an expensive all-weather camera that functioned at night — at the Leipzig Book Fair. Several color photographs were purchased for the Leipzig Museum by Seemann, a Leipzig publisher. The crowning moment in 1904 was the first prize and the Cross of Honor at the Paris Exposition in the Palace of Fine Arts. In 1906, to mark his thirtieth birthday, Sander exhibited one hundred large-format prints at the Landhaus Pavillon in Linz, drawing exceptional critical praise, and business at the studio boomed. The Linz *Tagespost* had this to say:

Lifelike postures, no pose, good groupings, the right grasp of the essential characteristics of a person, and excellent execution distinguish these pictures. The rigidly formal stu-

dio picture has vanished, the insipid retouching has ceased — these are no longer smooth faces, but expressive images.[14]

On November 7, 1907, the Sanders' second son, Gunther, was born and a few weeks later fell gravely ill with pneumonia. For the first time Sander seems to have recognized that his single-minded pursuit of business and artistic success was at the expense of his family. The baby recovered and the photographer took the entire family off on their first holiday. Also from that period, he began taking more pictures of his wife and children. He continued to exhibit, winning the state silver medal, the highest award, at the 1909 Arts and Crafts Exhibition in Linz.

In 1909, a polio epidemic erupted in Austria, and one of the victims was Sander's elder son, Erich. The family physician recommended that the family return to Anna's hometown, Trier. Sander relocated his wife and children, sold the business, and joined the Blumberg and Herrmann studio in nearby Cologne. Unable to put up with the limitations imposed on an employee, he soon left this firm and set up his own studio in the Cologne suburb of Lindenthal.

By now Sander had firm opinions about what he wanted to accomplish in his photography. At the opening of the new studio, he issued an advertising brochure, listing all his awards and medals, and proclaimed his basic photographic approach:

I am not concerned with providing commonplace photographs like those made in the finer large-scale studios of the city, but simple, natural portraits that show the subjects in an environment corresponding to their own individuality, portraits that claim the right to be evaluated as works of art and to be used as wall adornments.[15]

The public would have none of it, at least not at first.

With few customers coming to him, Sander set out to find business among the people who had provided his first small commissions. Not far from Cologne lay his native Siegerland and the adjoining Westerwald. He bought an old bicycle, filled a rucksack full of photographic gear and samples of his work, and pedaled into the countryside one Sunday morning. Sander knew the people of the area, that they would be dressed for church and in good family spirits on this sole day of rest. That first Sunday he garnered twenty customers. During the week, he developed and printed the pictures, returning the following Sunday. The peasants appreciated his efforts and his work, and for the next year he ranged through the Westerwald on his wobbly bicycle in search of business.

It was about this time, as he later recalled, that he first began to think about applying the physiognomic approach to portrait studies. Gunther Sander remembers his saying that the concept for "Man of the Twentieth Century" occurred overnight during the year 1910.

Gradually, the studio began to prosper, and Sander also received recognition, including an honorary diploma for distinguished achievement in a competition sponsored by the *Newspaper for German Photographers*. Nevertheless, he continued his excursions into the Westerwald, now seeking subjects for his own purposes more than for profit. The next year, Anna gave birth to twins, one of whom, a son, succumbed to dysentery — a common cause of infant mortality at that time. The other child was a daughter, Sigrid, who survived.

The year the war started, 1914, Sander was approaching one of his professional crests. The Berlin Museum of Arts and Crafts — preparing an exhibition to honor pioneers of photography worldwide — requested him to submit samples, and then purchased six photographs. In Cologne, a design association, the Werkbund, planned a major show linking industry, progressive architecture, and other artistic developments. Sander won the commission to provide the necessary architectural photographs.

When the fighting broke out, Sander, a reservist, was called up and assigned to the medical corps. His unit was dispatched to the battlefields of France and Belgium. Anna and the three children were left to fend for themselves. They survived by taking photographs of soldiers and keeping up contact with old friends in the Westerwald. Anna seized every opportunity to keep the business alive. When the local school was closed down, she and her three small children — Sigrid barely able to walk — packed along the camera, tripod and plates, and sold pictures to soldiers lounging outside the schoolhouse. Later, she reproduced and enlarged old photographs for families whose fathers, sons, and brothers had died in the war. Despite the wartime chaos, she even managed to get electricity installed in the house in 1918, just before Sander was demobilized.

At the conclusion of the war, Sander returned home to find business and family intact. He was now nearing his forty-second birthday, and Germany was on the verge of one of its most dramatic, tormented periods of change. Sander was just approaching the height of his powers, with a great and demanding vision of the work he could accomplish. The world around him might be ready to come apart at the seams, but Sander was entering the most productive period of his life.

As Sander began in earnest the period of work that would produce the bulk of "Man of the Twentieth Century," he drew consciously upon varied intellectual and cultural traditions. He was a curious man, a voracious reader, and the lack of formal education was for him more a spur than a hindrance. He filled his house with books, including some rare and ancient editions. Goethe was his bible, and he quoted the sage of Weimar incessantly in speech, letters, New Year's cards — even carving and painting favor-ite sayings on the furniture. Among the classics, he read in particular Schiller, Schopenhauer, Grillparzer, and Nietzsche; his favorites among the moderns were Rainer Maria Rilke, Stefan Zweig, and Thomas Mann.

A perusal of Sander's papers and articles — and also of the books that he had underlined — reveals no particular philosophical system. In his speech and his writing, the single word that he always returned to was *Wahrheit*, truth.

Nature, above all, was his guide, and he approached the natural world with reverence. Sander was fully attuned to Goethe's view that man was a part of nature, of the total

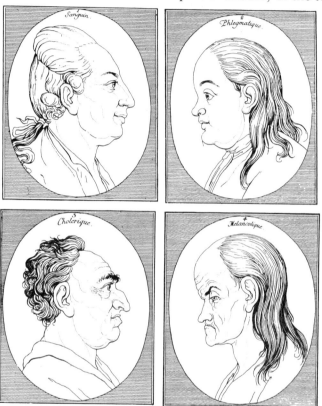

Engravings from Johann Kaspar Lavater's 1775 essay, "A Study of the Harmony Existing between Moral and Physical Beauty"

living organic unity of all creation. All of nature shared a divine energy, and all of nature was worthy of study. He undertook detailed studies of plants and wildlife, and also had a considerable reputation — both in the medical corps and among village children — as a man with a healing touch. Drawing upon his mother's herbalist teachings, he had a genius for nursing injured animals back to health. He was deeply interested in geology and the landscape, and in the heavy clouds that massed overhead. The totality of nature that he saw included the many faces of man in society — all part of a Goethean embrace of the whole of creation that searches out the underlying forms and patterns and follows their evolutionary development.

Alfred Döblin's brief, provocative introduction to *Face of Our Time* perceived the holistic influence on Sander as tracing back much further in European tradition. Beginning with a discussion of the opposing medieval schools of phi-

losophy — the Realists and the Nominalists — he presented Sander as an advocate of the former. Unlike the Nominalists, who believed in the uniqueness of everything and denied all generalities, the Realists believed, in Döblin's words, that "the great universals are active and real."[16] A keen eye is capable of extracting patterns and types that increase our understanding of reality. Sander's particular

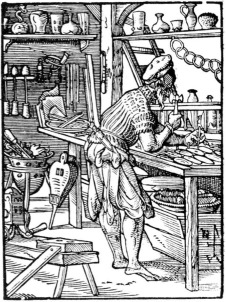

The glazier, a woodcut by Jost Amman from *The Book of Trades*, 1568

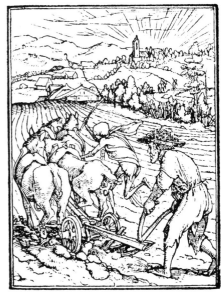

The ploughman, a woodcut by Hans Holbein from *Dance of Death*, 1538

mission was to reveal how the collective power of human society, social class, and cultural *niveau*, among other factors, produce group similarities and common types of appearances.

Sander also drew upon a European fascination, dating back to the Fifteenth and Sixteenth Centuries, with the depiction of various classes of society arranged in hierarchies by appointed function and trade. One traditional format

was the *Ständebüch*, or book of trades. (Actually, "trades" is misleading because the books included members of the social hierarchy such as pope, emperor, and king, who are usually conceived of in terms of rank rather than trade.) Such books were popular, especially during the Renaissance, and one of the most successful was the *Book of Trades*, published in 1568 with illustrations by Jost Amman and accompanying verses by Hans Sachs. Like Sander's work it was intended to portray society according to its various classes. On each page there is a picture of a representative of a certain rank or trade. Above the picture is the name of the trade, and below it a little poem describing the function of members of that group. The groups in the *Book of Trades* are arranged in order, following the medieval and Renaissance concept of estate and rank, beginning with the clergy (pope, cardinal, bishop, priest, monk, lay pilgrim); proceeding through rulers (emperor, king, prince, nobleman), the learned professions (physician, pharmacist, astronomer, lawyer), and the various artisans, craftsmen, miners, and peasants; and ending with the four fools — the money fool, the gluttonous fool, the jester, and the natural fool.

Sander devised his own hierarchical order, overturning the clergy and nobility at the top, and instead giving first position to the peasant as the foundation of the whole society, the most elemental class. But just as the Renaissance book ends with the fools, Sander's initial scheme ends with the "Last Men," including the idiot.

Another type of work showing all the classes and professions of society is the *Totentanz (Dance of Death)*, the most famous of which was by Hans Holbein the younger, published in Lyon in 1538. Again a representative of a particular group appears on each page with the name of the group or class above and verses below — but in every picture the subject is being attacked or threatened by the skeletal figure of Death. A work based on similar principles is the famous *Ship of Fools* by Sebastian Brant, published in 1494. Here the classes of society are portrayed, but in their folly. Each page shows a fool from a certain station in life, with satirical verses printed below. Finally, there is the *Spiegel* (mirror) tradition, in which a society or group is presented with a picture of itself, often critical and satirical, intended as a source of self-understanding and a guide to proper behavior. In this old tradition there have been "mirrors" of every type — mirrors of princes, mirrors of magistrates, mirrors of virgins, mirrors of fools, etc.

The essential difference between Sander's work and these earlier personifications was that they made no attempt to portray individuality expressed in facial features related to specific classes or trades. Sander attached great importance to this concept, which had attracted numerous great thinkers including Plato and Aristotle and fascinated such artists as da Vinci and Dürer. The most famous scholar of physiognomy in modern times was the Swiss pastor Johann Kaspar Lavater (1741-1801), admired by the young Goethe

and sought out by the emperors and kings of Europe. Lavater's fame arose from his *Essays in Physiognomy*, which were first published in 1772 and which by 1810 had mushroomed into sixteen German, fifteen French, and at least twenty English versions. A talented artist and indefatigable recorder of human faces, he attempted to produce a system of classification from which laws could be deduced concerning the relationship between face and mind. All men unconsciously draw conclusions from what they see in the faces of others, wrote Lavater, but the scientific physiognomist must learn his craft by precise, systematic observation and comparison.

Sander developed and expanded this concept by shifting the emphasis from individual psychological traits to traits shared by persons of common social, economic, and professional backgrounds. He changed the equation from "facial type A indicates individual character A^1" to "facial type A indicates members of social group A^1." Sander presented his photographs with only the briefest designation of occupation or social position. He did not select and classify elements in a person's appearance in words, but allowed the viewer to experience the shock of recognition for himself. He trusted that the prototype in the photograph would coincide with the viewer's impressions of the group or class represented.

Sander's physiognomic perspective also derived from Goethe's philosophical and poetical vision. For one of his New Year's cards Sander chose the following excerpt from the prologue to *Faust*, in which the archangels chant praises to the Lord and his creation. In Gabriel's song, we hear:

> *Unfathomably swiftly speeded,*
> *Earth's pomp revolves in whirling flight,*
> *As Eden's brightness is succeeded*
> *By deep and dread-inspiring night:*
> *In mighty torrents foams the ocean*
> *Against the rocks with roaring song —*
> *In ever speeding spheric motion*
> *Both rock and sea are swept along.* [17]

Thus, the archangel describes the earth, constantly changing from dark to light, buffeted by the conflict between rockbound shore and ocean wave. For Goethe, all nature was in the process of changing, evolving — shaped by the interaction of opposing forces. This sense of polarity lies at the heart of Sander's thought and art. Man and nature interact: nature forms man, and man in turn transforms nature. Society forms the individual, and in turn the individual transforms society.

Certainly, in the aftermath of the Great War, Sander experienced and documented the chaotic changes that man was imposing upon himself and upon the world around him. There was in Sander's work a sense of haste: Germany was losing emigrants, and already in his lifetime he had seen the irreversible shift from a rural society — close to nature and steeped in the communal values of the small village — to an urban society where the future, for good or evil, was being made in the cities.

Though his mind was filled with plans for the evolving "Man of the Twentieth Century," Sander's first order of business was to provide for his family. In the early days of the Weimar Republic, proclaimed as a constitutional democracy in the summer of 1919, survival depended upon hard, sometimes desperate effort. Germany was undergoing a harsh transformation. All its colonies were seized by the victorious Allies, and France, Belgium, and Poland annexed

Photomontage of Sander's Cologne studio-home
at Dürenstrasse 201 c. 1935

sizable territories of the homeland. The Rhineland, in particular, was subjected to a brutal occupation by the French. The precarious German economy was even further weakened by heavy reparations payments — with the accompanying political and social burdens — imposed by the Versailles Treaty.

The next few years were filled with domestic violence and an unyielding foreign presence in German affairs. Machine-gun fire blazed over the rooftops as internal disputes broke out between the right-wing and leftist political factions. Claiming the defeated nation was behind in its payments, the Allies demanded 132 billion gold marks. A shortage of gold — combined with disastrous balance of payments deficits and the flight of capital — spurred the legendary inflation that rocked the country. In January 1923, Poincaré of France instigated occupation of the industrialized Ruhr Valley, and Belgian and French troops operated mines and

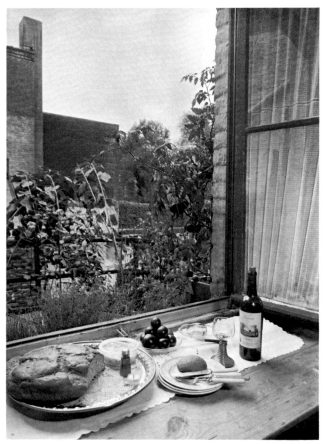

Sander's lunch table in Cologne study c. 1938

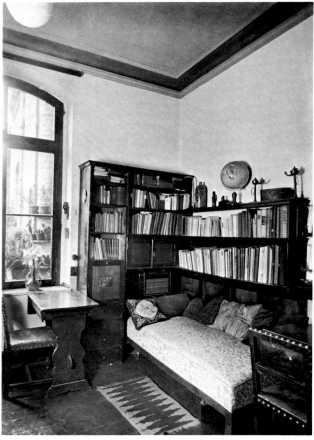

Corner of study where Sander read and napped c. 1938

Retouching desk in study c. 1938

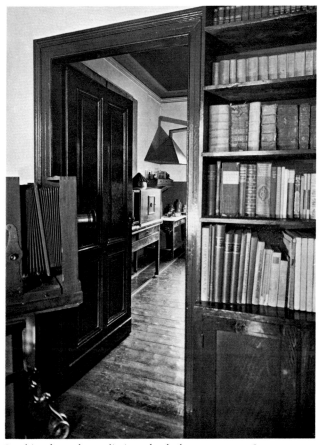

Looking from the studio into the darkroom c. 1938

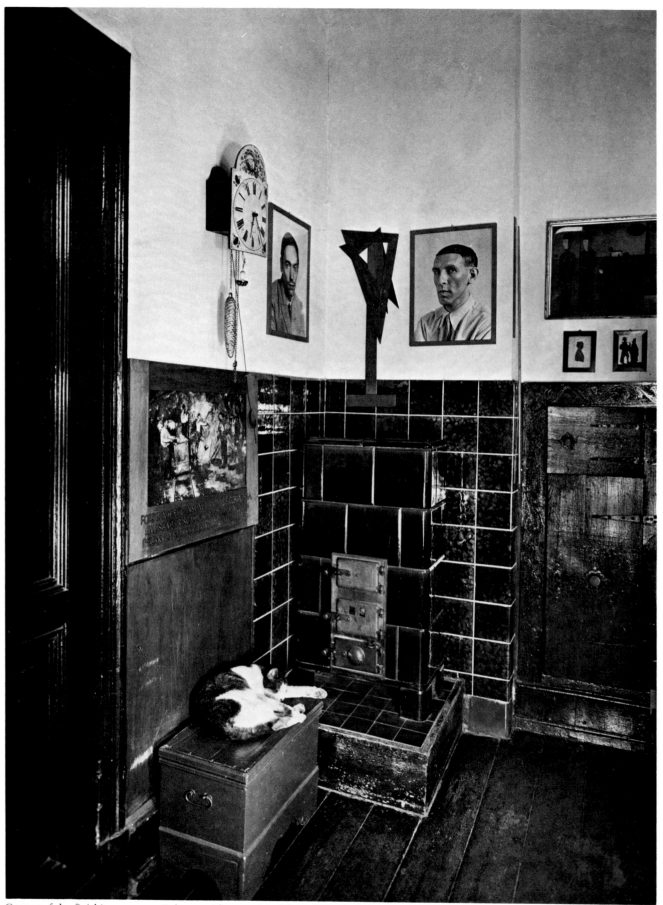

Corner of the finishing room at Cologne with portraits of Franz Wilhelm Seiwert and Heinrich Hoerle c. 1938

industries on behalf of the Allies. Clashes between the occupying troops and workers broke out, the workers mounted a campaign of passive resistance, and production came to a virtual standstill. Farmers refused to ship food to market, industrial output plummeted, and food riots broke out as the cost of a loaf of bread soared to millions, then billions, and finally trillions of marks.

Sander opened up a new clientele among the Occupation troops, particular contingents from Canada, England, and New Zealand, who presumably were able to buy their souvenir photographs with valuable foreign currency. He also resumed his sorties into the Westerwald, where his old cus-

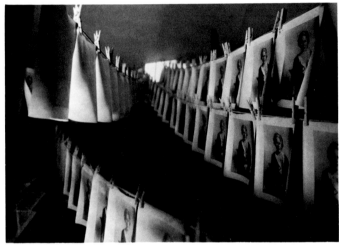

Commercial prints drying in attic c. 1938

tomers welcomed him back, loaded him with work, bartered in part with foodstuffs from their farms.

Despite the hardships, Sander also began to create the type of milieu that best suited his sometimes extravagant tastes. There was in his personal style a distinctly bohemian strain, a Romanticist's bent. Though photographs make him look imposing, he stood in fact only five feet seven inches tall. He grew in his younger years a beard and mustache — carefully groomed and waxed to fine points. The facial hair was gone now, and the broad-brimmed black hat of earlier days had been replaced by a beret. In 1920, he was determined to acquire a *Wasserburg* — one of the many old castles whose moats had dried up centuries before. He plied Anna with schemes for renovation and for taking in summer guests to help meet the costs. It was soon apparent that the venture was prohibitively expensive, and to her relief he reluctantly abandoned the plan.

Nonetheless, Sander fashioned an extraordinary environment. He was determined to live surrounded by beauty and rich, bold colors. In the Cologne house, the floor was red, the ceiling blue, and the walls and panels were white with green borderings. The walls were decorated with several of his photographs and paintings, and also with works of artist friends who exchanged paintings for his photographic reproductions of their work. He was a passionate antique

collector — again, often to the despair of Anna, who fretted over the splurges. Some of these pieces he bought in battered, unrecognizable condition and restored, occasionally selling an item for profit. Other furniture he made himself, including elaborate Gothic bedsteads. For his wife and children, Sander designed loose, free-flowing clothing, which Anna sewed. In a period when corsets and stays were still in fashion, such garments gave the family a decidedly artistic appearance.

The house was always filled with a menagerie, including wild animals Sander nursed back to health. Along with the dogs, cats, and chickens, there was an owl — who frequently startled unsuspecting customers — and, for a while, a hedgehog, later evicted after being identified as the source of fleas. (Years later, when the Sanders moved to the country at the outset of World War II, there was Köbes, a magnificent crow whose broken wing Sander mended. In good weather, Sander would take his afternoon nap on a bench outside, and Köbes would cover his master with leaves and watch over him as he slept. Köbes remained for fourteen years, until he died, when incessant cawing was replaced by an eerie silence.)

Sander's own satisfaction in his surroundings was evident in a letter written to his uncle from the Cologne house:

At this moment I am sitting in our parlor at a heavy old table that came from Reichenstein Castle in the Westerwald: around the table stand old chairs from the Sixteenth Century, in the left corner a bookcase that bears many a dear friend. To the left of the doorway an old chest, and on the right an old Rhineland wardrobe from the Sixteenth Century; straight ahead, that is, in front of me, the Christmas tree, with a view through a tall window onto a quiet street; in the right corner, beside the window, a couch built into a wooden wall, with wood paneling and old pewter ware, old hand-painted pottery.[18]

It was in these early years that Sander began making acquaintances in the Cologne art circles. Politics and art were virtually inseparable in the climate of Weimar, and most of his friends were Progressives, with leftist leanings. One painter, his close friend Franz Wilhelm Seiwert, was on hand when Sander experienced one of his most fortuitous "accidents." Making an enlargement of one of his peasant studies, Sander ran out of his usual paper and was forced to print on the hard, glossy paper he used for detailed architectural and industrial pictures. The resulting portrait emerged with a clarity he had not previously achieved in his portrait work. Seiwert was quick to point out that he had in fact made an important aesthetic breakthrough, and encouraged Sander to continue with the technique.

The Cologne artists were divided into two factions. One group, called the Progressives, introduced abstract distortions into essentially representational paintings, reducing

human images to simplified geometric forms. It was a fascinating direction for leftists, departing as they did from the commoner approach of Socialist Realism. The faction that subscribed to what was dubbed the New Objectivity, on the other hand, were cool realists. Despite heated disputes, both groups were united by the conviction that artists must help bring about a new social order and discover new means of expression that would be relevant to the masses.

Many critics have claimed that the New Objectivists, in particular, influenced Sander's work. In fact, he benefited mainly from the lively atmosphere and the intellectual ex-

Group exhibition poster designed by
Sander, using his own silhouette

changes. Sander's photographs were more in the tradition of the Realist painter William Leibl, also a hero to the New Objectivists. Born a generation before Sander, Leibl achieved considerable fame before his death in 1900. Leibl's most frequent subjects were peasants, whom he painted full face and without a whit of Romanticism. "If we paint man as he is," Leibl had said, "his soul is included as a matter of course."[19] In addition to this physiognomic attitude, Leibl also anticipated Sander's own preoccupation with truth, no matter what its guise. As Leibl put it, "I want to paint what is true, and people consider that ugly, because they are no longer accustomed to seeing the truth."[20]

Though Sander was a generation older than his Cologne colleagues, he was accepted as one of them and exhibited in their shows. The painter Gottfried Brockmann actually lived with the Sander family for two years, and on most evenings the Cologne house was filled with artists. Anna would prepare huge pots of goulash, and the men would settle in for an evening of talk, food, beer, and wine — including Sander's own homemade rhubarb wine. Among

his many interests, Sander was also an accomplished musician — he once even considered a career as a concert lutenist. German folksongs formed his basic repertoire, and most of these convivial evenings concluded with a songfest.

Politically, too, Sander was linked to the Cologne Progressives, but he never felt particularly comfortable with the association. He insisted to Brockmann that he sought a socially critical, not proletarian art — and that there was no political intent. It is far more likely that Sander influenced his friends, for example, in the formal frontal poses used by Otto Dix in *Mother and Child* and in Erwin Merz's *Portrait of My Grandparents*. Throughout the period, the Cologne artists gave moral support and advice. And Sander was on hand to photograph their paintings and also the annual revelries of the *Lumpenball*, the artist's Mardis Gras ball. It is in the Mardis Gras pictures that we find the only trace of anything remotely erotic in Sander's work. He had at first balked at the idea of photographing the artists at their pleasure, but the prospect of instant cash payments for his work was suitable inducement.

In 1926, Sander met Ludwig Mathar, an established author of a book on Italy and various works of fiction. Mathar was so impressed by Sander's photographs that he suggested a collaboration on a book about Sardinia. The next year the two set out on the expedition, and Sander returned after three months with hundreds of photographs. Mathar and his publisher were unable to conclude an agreement, however, and the book never materialized. The result of one of Sander's rare photographic excursions outside Germany was a newspaper article written by Mathar with Sander's pictures as illustrations.

It was also in 1927 that Sander first formally announced his great project, "Man of the Twentieth Century." The occasion was an exhibition of modern painting, sculpture, and photography, sponsored by the Cologne Art Association. Sander's entries were a huge success at the show, and he also contributed — along with the photographs — a short essay that described both his project and the credo upon which it was based:

People often ask me how I came upon the idea of creating this work: seeing, observing, and thinking – and the question is answered. Nothing seemed to me more appropriate than to project an image of our time with absolute fidelity to nature by means of photography. We find writings and books with illustrations from all ages, but photography has provided us with new possibilities and tasks, different from those of painting. It can reproduce things with grandiose beauty, but also with cruel truthfulness; and it can also deceive incredibly. We must be able to endure seeing the truth, but above all we should pass it on to our fellow men and to posterity, whether it be favorable or unfavorable for us. Now if I, as a healthy human being, am so immodest as to see things as they are and not as they are supposed to be

24

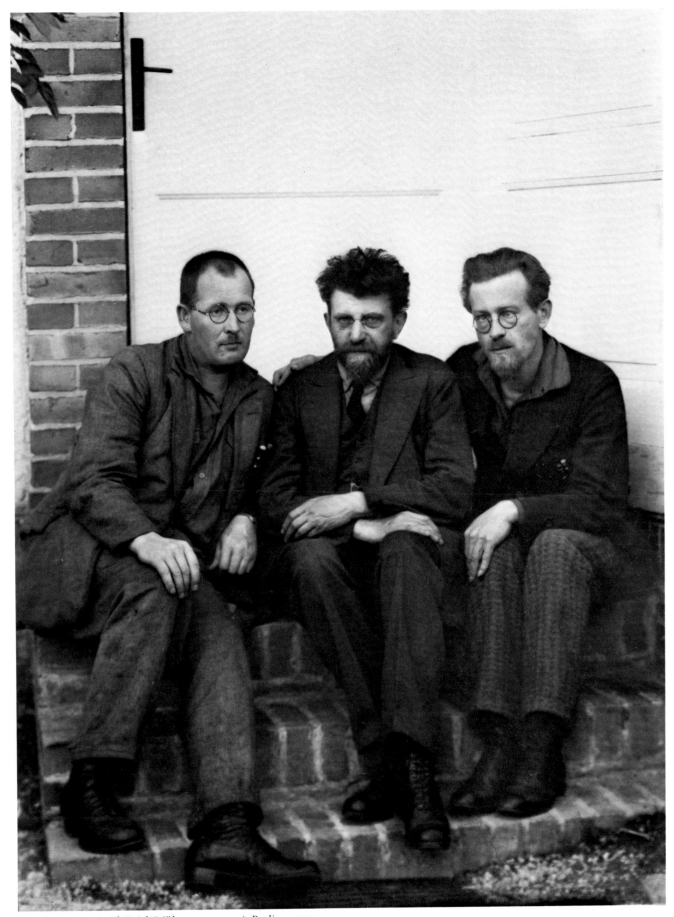

Revolutionaries (with Erich Mühsam at center), Berlin 1929

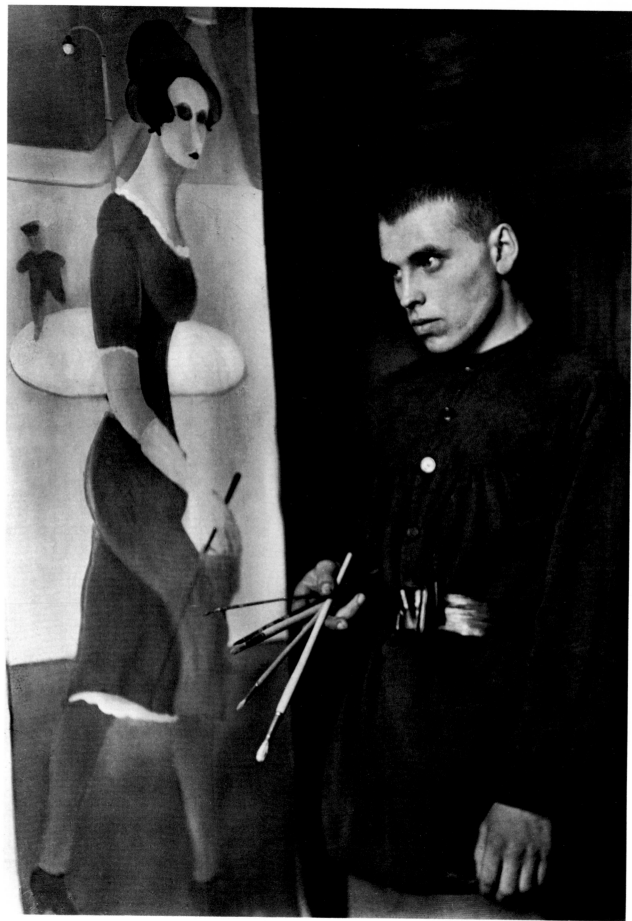

Painter Gottfried Brockmann, Cologne c. 1924

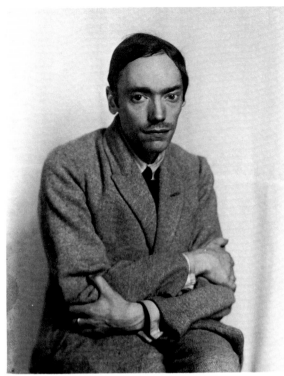

Painter Franz Wilhelm Seiwert, Cologne 1928

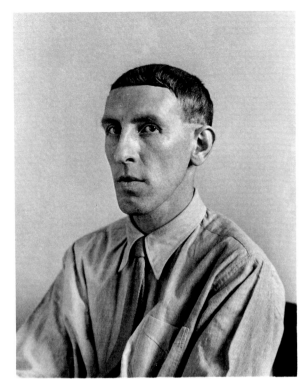

Painter Heinrich Hoerle, Cologne 1928

or can be, then I beg your pardon, but I can't act differently. I have been a photographer for thirty years and have engaged in photography with the utmost seriousness; I have taken good paths and bad paths, and recognized my errors. The exhibit at the Cologne Art Association is the result of my search, and I hope that I am now on the right path. Nothing is more hateful to me than photography sugar-coated with gimmicks, poses, and false effects. Therefore, let me speak the truth in all honesty about our age and the people of our age.[21]

Meanwhile, Sander's children were growing up. He had a great love of children, and was something of a hero in the neighborhood for his ability to cure sick pets and tell stories. When a youngster who was spending the night at the Sanders' cried out in fear of the dark, Sander would lay a *Knüppel* — a stout German walking stick cut from a tree — by the child's side. "Now," Sander would whisper conspiratorially, "if you should see anything in the dark, you can frighten it away."

Sander's own children, however, often chafed over his strict, disciplinary ways. The "work first, play later" approach to life translated into niggling, arbitrary tasks that kept them from play. Erich and Sigrid especially had tempers and independent spirits that, matching their father's, often kept the house in an uproar. At the same time, Sander was a devoted, sentimental father, proud of his children and loyal to them above all others. During one shouting match with Erich, Sander struck his son in the face, and then, shocked, locked himself in a room and wept for hours in remorse. He frequently embarrassed his children by stalk-

ing people on the streets who interested him as photographic subjects. Sigrid was the child who inherited his passion for art. When she was little more than a toddler, Sander bought her an easel, and they painted side by side. Oil painting was one of Sander's chief pleasures throughout his life, and he was quite adept at making extra money by painting on demand a seascape, a landscape, or an animal scene to match a patron's décor. Sander wanted Sigrid to become a photographer, and for a couple of years she worked with him. But she could not tolerate his incessant, dogmatic supervision, and finally refused to have anything more to do with it. In adult life she became a respected potter. She recalled, though, that those sessions with her father proved helpful in picking up much-needed jobs in photography laboratories.

There was no formal religious training — and no church-going — in the Sander household. At the same time, there often were as many clergymen, including priests, rabbis, and pastors, as there were artists on hand for dinner. Sander insisted that his only religion was nature, but enjoyed the company of well-educated clergy. Also they were, in a way, working colleagues. In German households, it was customary to call in the photographer along with the cleric to attend all major events in life: christening, confirmation or bar mitzvah, and wedding. Photographs were also taken of the deceased, laid out in state, the household of the bereaved, and of the final funeral journey and interment.

Amid the frequent quarrels in the Sander household, Anna and Gunther were the main peacemakers. Sander's second son was the family athlete and the one to take up his

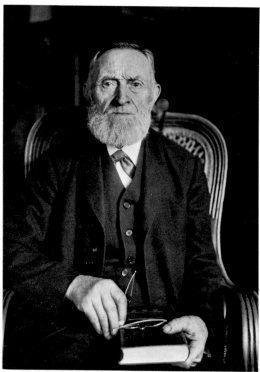

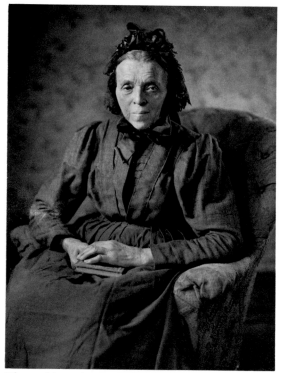

The revolutionary, from "Stammape" c. 1911

The earthbound woman, from "Stammape" c. 1911

father's profession. All of the children were given extensive musical training. Erich and Sigrid played the guitar, and Gunther was sufficiently accomplished as a cellist to study for a while with a member of the famed Adolph Busch quartet, which toured Europe and North America.

Sander's fears for his children's future began to intensify as the decade drew to a close, with the first, incredible hints of the Nazi rise. The continual upheavals of the Weimar period created an atmosphere of expectation. There was a yearning for a strong leader who would set things right, and a renewed interest in the old legends surrounding the *Führer* to come. One of the most compelling myths was that of Frederick Barbarossa, sleeping in a Thuringian mountain, awaiting the time to rise and guide the German people. Nor was Sander immune from such yearnings. In one letter to his uncle, he wrote:

On my return trip [from Darmstadt, where he was to photograph the Grand Duke of Hessen-Nassau] I want to go to Herdorf, by way of Giessen, and find out how things look there. Unfortunately, conditions are supposed to be very bad. It is really a pity about that fine breed of people; the best ones are emigrating to America, and America can pick out the best of them. The emigrant type in my work "Man of the Twentieth Century" will be from the Siegerland, he will represent all the qualities of the highest stage of human development; for I know what he is and I have seen him often, this splendid human type; but the German leader [Führer] is sleeping an unjust sleep. As I conceive of the leader, he cannot belong to any political party; that would be impossible for me. All party men are small-minded peo-

ple who have run astray. Only time will tell whether he is coming. But I intend to open the eyes of all men with my objective eye.

You will detect a love of my homeland in what I have said, but this love shall serve mankind in general, not merely certain individuals.[22]

Obviously, Sander's conception of the *Führer* was nothing like the coming experience.

In November 1923, Hitler had attempted his famous beer-hall *Putsch* in Munich; the venture failed and he was imprisoned for high treason. Some economic relief for Germany was promised in the Dawes Plan, an American proposal to evacuate the Ruhr, to reduce reparations, and to extend loans to Germany. The Wall Street collapse of 1929 ended any hope for relief. Loans were cut off, German exports dwindled, and bankruptcies and unemployment increased to enormous proportions. Such developments cut heavily into Sander's architectural and industrial photography commissions. It was also in 1929 that the first Nazi Party member was placed in a major political post. Wilhelm Frick was named Minister for the Interior and Education in the province of Thuringia, and immediately launched attacks against modern "Bolshevist," "Marxist," "Jewish," and "degenerate" art.

Sander's chief concern was for his elder son. Erich had grown into a tall, slender, reserved youth with a pronounced limp. His childhood bout with polio had so badly crippled the boy's leg that his foot was twisted almost upside down. A brilliant operation performed in 1918 by a Berlin surgeon partly corrected the condition. Despite the

handicap, he took long hikes and biking expeditions into southern Germany, Austria, and Italy. Encouraged in part by his father's socialism, he had in his teens turned his attention toward the poor and oppressed, and for a while joined the Communist Party. After entering the University of Cologne in 1923, he became an activist in the Socialist Worker's Party.

Though distressed at the growing Nazi sentiment, Sander was also a rigorous adherent of the idea that man lives in, and is responsible to the community. He was deeply concerned about Erich's antigovernment activities, and it was the cause of their most violent arguments.

The increasing Nazi presence also raised fears for Sigrid's safety. She had joined the ballet corps of the Cologne Opera House, dancing, among other things, a nymph in *Tannhäuser*. Sander delighted in Sigrid's Terpsichore. But when thugs began throwing stones at Jewish singers on-stage, and police escorts were needed to help performers leave the opera house safely, he begged her to quit. It was, he felt, too dangerous.

They had their share of quarrels, but Sander probably opened his inner feelings, and showed more of his true sentimental makeup to Sigrid than to his other children. At eighteen, when she was preparing for her first solitary journey — a vacation trip to Norway — Sander called her aside for a lecture. "Sigrid," he said, "you are a young woman going off into the world. You will meet people. Things may happen. Though we should try not to let such things happen, we sometimes get carried away. It is in our nature, and it is nature's way. If anything does happen, don't run. Come home. Always come home." Implicit in the conversation, Sigrid later recalled, was the simple message: if you get pregnant you should always come back to us, without shame. Later, in a letter to his daughter, Sander wrote: "It is always difficult for me to speak about myself, and I can open my heart and soul only to someone in whom I have great trust."[23]

With the exhibition and subsequent publication of the *Face of Our Time* Sander's reputation attained a national dimension, and social critics drew upon it as insightful expression of the changes occurring in German society. An excellent representative review, worth quoting at some length, was Paul Bourfeind's 1928 article in the *Reinische Blätter für Kulturpolitik*:

The peasant, bound as he is to the earth, is the energy source for the industrial big city. The superabundance of unbroken will to live is fleeing from the country to the city. To the extent that man removes himself from nature, he becomes more complicated, consumes himself, and uses himself up. Two or three generations suffice to reveal this process of decay, and Sander's pictures surprisingly show this transformation in sequence. Here before the viewer stand pictures of peasants with an inner wholeness almost un-

known to people from the large cities. With all their internal and external constraint, there stirs in certain of these nature-chiseled faces that openness of mind that leads to deterioration when it is passed on to the descendants as a fatal inheritance and when amid the new and different conditions of the large city it develops one-sidedly to a certain specialization that is alienated from nature. This deterioration represents only the necessary result of the high level of development that we think so much of. The tragedy of human evolution becomes apparent. From peasant connectedness there grows over many stages the unconnectedness of the large city. The individual's sense of oneness with his family and the world around him turns into the fragmentation in all classes of an uprooted society.... Is this all leading up to the point where we will meet again the people in the last portfolio, the "Last Men"? Is the idiot – with all the instinctiveness of his vital powers, concerned only with self-preservation. Is he to be the last? After this detour, in which he has departed from nature, shall man again return to her bound in this way?[24]

A more prescient commentary in view of the troubles Sander later had with the Nazis over his book was Walter Benjamin's review in his "Brief History of Photography," written in 1931:

Works like those of Sander can acquire unexpected contemporary significance overnight. Fluctuations in power, for which we are now due, customarily make the development, the strengthening of the physiognomy concept a vital necessity. One may come from right or left – one will have to become accustomed to being regarded according to one's origins. One will also, conversely, have to regard others in the same way. Sander's work is more than a picture book: it is a training manual.[25]

In August 1931, Sander was invited by West-German Radio (WDR) in Cologne to give a series of six talks on photography. He was both skeptical and unsettled. Up to that time, he had written no articles, nor given any lectures about photography, and yet he was intrigued by the idea. He and the station agreed upon the fee, and the lectures were titled *The Nature and Development of Photography*. Sander buried himself in his books and began to dictate the first of the lectures. Erich tried to help his father correct a rather clumsy style, and Sander lost his temper. Anna and Gunther then stepped in, reading back to Sander what he had dictated, and again Sander flew into a rage — insisting that he had said nothing of the kind.

The first microphone tests, too, were dismal experiences, but the photographer refused to let a trained radio announcer substitute for him. Sander arrived at the studio and launched into his lecture. Despite a mild sedative urged by the family for its tranquilizing effects, Sander dived into his subject with such gusto that he managed to condense the

entire twenty-minute talk into thirteen minutes. For listeners, there was a period of silence, and then they heard the speaker's indignant voice, "Well. What happens now?"

Sander decided to allow professionals to deliver the rest of the lectures, and the incident became a favorite family anecdote. The talks remain of considerable importance because he was able in them both to formulate and to articulate his concept of photography.

The first lecture dealt with the history of photography and the discoveries and inventions that had led to the first successful achievements by Daguerre and Niepce. In his second talk, Sander considered pre-1900 photography, describing its role in society, the involvement with business and science, and the rise of the professional photographer and his methods.

In the third lecture, Sander discussed what he called "the blooming of kitsch" around the turn of the century, when wrinkles and blemishes were brushed away in the studio to soothe the vanity of the subject. Sander then took up the crucial question of aesthetic values versus fidelity to nature:

The essence of all photography is of a documentary nature, but it can be uprooted by manual treatment. In documentary photography, the meaning of what is being represented is more important than the fulfilling of aesthetic rules of external form and composition. Nevertheless, both principles – that of aesthetics and that of documentary fidelity – can be combined in their application in various areas. But photography has the right to be called documentation only when we keep to the chemical-optical way as carefully as possible: i.e., when we achieve the pure configuration of light with the aid of chemical and optical means. If we compare, we will ascertain that a photograph produced with the aid of chemicals is far more aesthetic than one muddled by artificial manipulation. [26]

In the fourth and fifth lectures, Sander explored the role of photography in the sciences, and then related the medium to its role in international cooperation—his view of photography as a universal language:

All science is dependent on international cooperation, and similarly its results are of importance to all civilized nations. It is obvious, therefore, what significance photography could have for science, as an aid whose comprehension is not limited by narrow national boundaries as is, for example, spoken presentation. [27]

To illustrate the possibilities of photography as a sort of visual Esperanto, Sander suggested a gripping image—one that would immediately communicate the inhuman spirit of the modern age:

The newspapers are now preparing the populace for a coming bestial war in which poison gas will be used; they recommend gas masks to protect the lives of the civilian population. To photograph an infant wearing a gas mask, instead of being at its mother's breast, and to label the photograph as being from the Twentieth Century would be sufficient. It would express the whole brutal, inhuman spirit of the time in universally comprehensible form. [28]

After a detailed discussion of his own view of physiognomy in its personal and sociological sense, Sander then went on to apply the concept to landscape and architecture. He concluded the series with his own criterion for assessing photography as art:

Pushing a button implies that one relies on chance; taking photographs means that one works with forethought, that is, tries to understand a scene or to bring a concept out of its beginnings into a complex of ideas with a finished form. [29]

In sum, art depends upon the successful expression of the photographer's conscious intent to communicate the meaning of his picture.

In January 1933, aging President Hindenburg named Adolf Hitler Chancellor, and the Third Reich began. Like many of his countrymen, Sander was deeply distressed, and felt the impact immediately in his own family. Erich and his group of activists were forced underground, and the young man began monthly bicycling trips to Paris, to help arrange escapes. At the time, he was nearing the end of his doctoral studies at the University of Berlin in political science and military history.

While Erich was away, the Gestapo queried Sander about his son. Anxiously, his parents advised Erich not to return to Germany, and Socialist Worker Party leaders made plans for him to emigrate to Norway. However, Erich preferred to continue the struggle in his homeland and returned to Cologne. His father helped him produce leaflets by photographic means, since the party press had been seized. Because Sander did not own a drying machine, they dried prints on the roof. A gust of wind blew some leaflets into the courtyard below, which were picked up by someone sympathetic to the Nazi cause. At 4 A.M., on a chill September morning, the Gestapo raided the Sander house and took Erich away. He was subsequently tried, stripped of all university honors and credentials, and sentenced to ten years in prison.

In a subtle way the political atmosphere influenced Sander's work. In 1933 and 1934, he published a series of five books of photographs, entitled *German Lands, German People*, writing the texts for four of them. The original German title, *Deutsche Lande, Deutsche Menschen*, had been altered in the last three volumes to *Deutsches Land, Deutsches Volk*. The English translation for both might be the same, but the later title, employing the singular form and the work *Volk* — with its mystical echoes of race and tribe — suited prevailing Nazi attitudes far better than the plural *Menschen*, with its connotation of human beings, of whatever stock.

For Sander and for millions of his countrymen, the

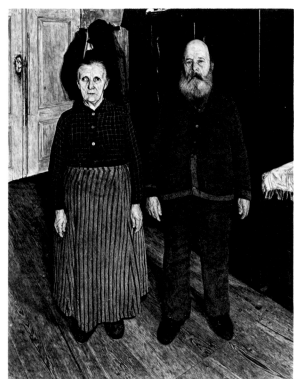

Portrait of my grandparents by Erwin Merz

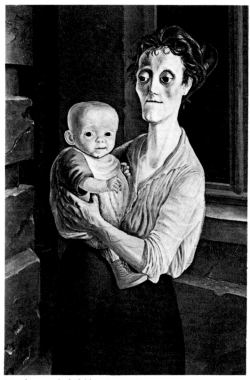

Mother and child by Otto Dix 1921

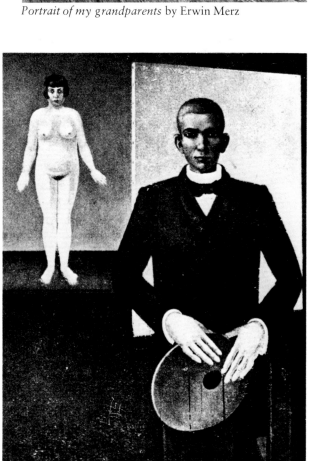

Painter and model by Anton Räderscheidt

Machine men by Heinrich Hoerle 1930

Weimar Republic had met a death felt immediately and brutally in everyday life. Sander witnessed the imprisonment of his son, and the suppression of his work, and he lost through flight or murder most of his friends and colleagues.

The turbulent fourteen years of the republic had been a period of devastating economic and social hardship. Yet, the Weimar period also provided the background for one of the most creative outbursts of Western civilization.

In those first years after World War I, feelings of optimism clashed and blended with currents of profound pessimism. On the one hand there was unbridled delight at the potentials provided by the rapid spread of modern means of communication and transportation—radio, movies, scheduled airline flights, etc. — and a new feeling of exciting social freedom, release from old ties and taboos; on the other hand there was a mood of sadness at the loss of the old order, the old refinement, and a fear of the new, leveling technological age. The coolest, most rational objectivity, the utmost in geometric clarity stood side by side with the remnants of Expressionism, utopian dreams, and fantastic cults.

The basic texts of modern existential philosophy appeared at this time: Karl Jaspers' *Philosophy* in 1931, and despite its complexity, the even more famous *Being and Time* of Martin Heidegger in 1927, which provided the basis for Jean Paul Sartre's popularization of Existentialism after World War II. Science flourished at the university and industrial-research centers, and at special institutes for pure research. In 1918, the birth year of the Weimar Republic, Max Planck was awarded the Nobel Prize in physics for his formulation of the quantum theory. Einstein followed him as prizewinner in 1921. Remarkable breakthroughs were achieved in totally new areas, such as Hermann Oberth's formulation of the first scientific theory of space travel in his 1923 book *Rockets to Outer Space*. In 1925 Werner Heisenberg, Max Born, and Pascual Jorden developed quantum mechanics, with Heisenberg receiving the Nobel Prize in 1932.

Some of the supreme authors of the Twentieth Century completed their greatest works during this period. Among them were three Austrian-born writers who never received a Nobel Prize, though they were of far greater stature than many who did receive it. In 1923, Rainer Maria Rilke, perhaps the greatest poet of the age, finished his *Duino Elegies*. Franz Kafka died in 1924, and two masterpieces, *The Trial* and *The Castle*, were published posthumously in 1925 and 1926, respectively. Robert Musil published the first volume of his massive work *The Man without Qualities* in 1931. Of the German-born writers, Thomas Mann completed *The Magic Mountain* in 1924, and for this work primarily, he received the Nobel Prize in literature in 1929. In 1920,

Hermann Hesse published *Glimpse of Chaos*, a work that deeply impressed T. S. Eliot, and in 1927, he completed *Steppenwolf*, perhaps his finest novel. The two greatest names among playwrights of this period were Georg Kaiser, the exponent of intellectual, ethically oriented Expressionist drama, and Bertholt Brecht, whose *Threepenny Opera*, with music by Kurt Weill, more than any other work epitomizes for American audiences the prevailing spirit in Germany at the time.

Musical life, traditionally rich in Germany, flourished in the tension between the traditional Nineteenth Century sound most favored and the new music. Men like Wilhelm Furtwängler and Otto Klemperer conducted the major symphony orchestras, and modern music celebrated great tri-

Self-portrait by Hannes Maria Flach

umphs at the premiere of Alban Berg's shocking atonal opera *Wozzeck* in 1925, and at the first performance of works by Paul Hindemith and Kurt Weill.

The most famous center of creativity in the period was the Bauhaus, founded in Weimar in 1919, which set out to combine art with industrial production and to look for new forms in architecture and industrial design. This institution, which gathered together the greatest talent of the age, closed down when the Nazis came to power, but it left its imprint on all areas of modern life from coffee cups to urban planning. Walther Gropius, its first head, was a uniquely creative architect in his own right, working in clean, spare, unadorned geometric forms. One of the great achievements of modern urban housing design is the Weissenhof Settlement near Stuttgart, where Gropius collaborated with some of the finest architects alive: Mies van der Rohe, Hans Scharoun, and Le Corbusier. Sander's friend Hans Poelzig

Leaves of a ginkgo tree c. 1932

Advertising photogram for German glass company c. 1932

created the most powerful of Expressionist architecture with his Great Theatre in Berlin.

In painting, many different currents flowed together. Expressionism and its offspring Dada, Surrealism, the New Objectivity, and various approaches to abstraction kept the art scene lively and varied. In the course of the decade, Expressionism was largely replaced by other movements, mainly the New Objectivity and to a lesser extent abstraction. But even in the New Objectivity some of the Expressionist passion remained, as in the bitter pictures of wounded veterans by Otto Dix, or in the heartless boorish capitalists and victimized workers portrayed by George Grosz. Max Beckmann also revealed a probing ferocity in his visions of a debauched modern society. Max Ernst, who originally came from Cologne but later moved to France, was the most original among the Surrealist painters; while Paul Klee inhabited a unique artistic land of his own, bordering on Ernst's Surrealism, Wassily Kandinsky's abstraction, and the naïve drawings of children. Kandinsky himself had returned to Germany after the war and taught at the Bauhaus with Klee.

German directors created powerful and original films that gained worldwide fame: Robert Wiene's *Cabinet of Dr. Caligari* (1919), the most successful Expressionist film, Fritz Lang's *Metropolis* (1926), Josef von Sternberg's *Blue Angel* (1930) with Marlene Dietrich, G. W. Pabst's *Threepenny Opera* (1931) are among the most unforgettable film experiences.

New directions opened up in photography. From 1918 to 1928 photojournalism experienced a rapid development with the perfection of the small camera, and photographers gained a great deal more freedom and versatility. Photography was carefully integrated into the overall design of newspapers such as *Berlin Illustrirte*, where the editor, Kurt Korff, encouraged a more subjective, personal style.

In 1929, the same year as the publication of Sander's *Face of Our Time*, another work of great importance in the history of photography appeared: *Foto-Auge*, a collection of seventy-six photographs exemplifying modern techniques and approaches. Most of the photographers had aimed at achieving striking and unusual effects by the use of unusual distances and angles. The photographs are generally visual treats: extreme close-ups, aerial shots, photomontages, photograms, time exposures, and collages combining photographs and paintings. Some are static views of things that are normally seen only in motion, some are carefully planned arrangements of incongruities, but one thing is common to all of them: they are concerned, not with an idea, but with a kind of visual titillation, brilliant though they are. They did not, however, aim at the truth in the way August Sander would pursue it.

Against this dazzling background, Sander seems an outsider. His main connection with the great artistic movements of the Weimar period was his social awareness which was reflected in his photography. This is perhaps due to the fact that Sander reached maturity in the 1890s. His is a full generation older than most of the artists and photographers who came to fame during the 1920s. Partly for this reason and partly because of his temperament his work hardly reflects the most advanced artistic currents of the time.

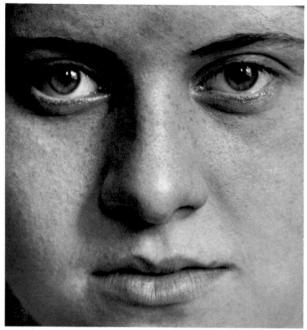

Sigrid, from "Organic and Inorganic Tools of Man" c. 1953

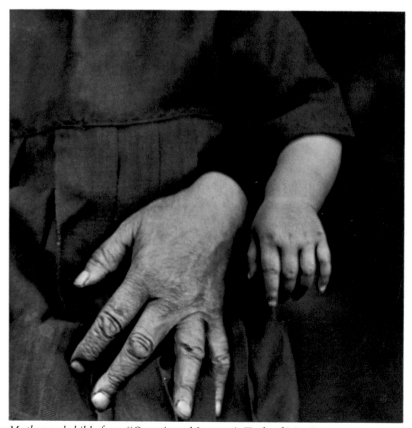

Mother and child, from "Organic and Inorganic Tools of Man" c. 1953

The popular image of the Weimar period centers on frivolity, dissipation, and depravity. Although considerable loosening of the social fabric occurred, it is not accurate to portray the essence of Weimar culture under the heading of transvestite balls and Hollywood versions of a German cabaret. Certainly frivolity, dissipation, and depravity were to be found at the time perhaps even more than in most other European countries, and yet the country had managed to remain basically bourgeois: both genius and perversity were the exception rather than the rule.

In his anger and grief after Erich's arrest, Sander found some consolation on camping trips to the Siebengebirge district. There he often spent the night in his sleeping bag, photographing during the day and taking some comfort in the beauty of the unspoiled land. He found a cave that offered shelter, cleared out its interior, set up a cot, and built a cement entranceway with a locked door to create a residence in the wild. He was producing a volume on the flora of the Siebengebirge that was to include plants then extinct, and he found seeds of exotic varieties and sowed them around the entrance to his cave. Occasional hikers who happened to pass were amazed to see columbines and tropical lianas and orchids growing in a remote part of the Siebengebirge.

Sander now devoted his attention almost exclusively to landscapes, and the photographs taken for *German Lands, German People* and afterward offer the most accessible images of what he meant by the physiognomic approach to the landscape. Though Sander was capable of capturing unspoiled stretches of scenery with a beauty to satisfy any Romantic, his chief concern was with the landscape reformed, its spirit altered, by the hand of man. It is as a landscapist that Sander's disinterest in dividing art and science into mutually exclusive categories is most evident. In fact, it was another characteristic that he may have drawn from Goethe — the blurring of the art-science boundary lines. At his best, Sander managed to blend history, geology, and contemporary land usage into striking images.

He published a fascinating newspaper article, illustrated with his own photographs, about an ancient method of communal farming that was practiced by the peasants in the Siegerland. He related this method to its ancient origins and to the historical developments that had affected it. He showed how modern peasants had derived their approach from old Germanic methods of communal agriculture. He also explained how the rise of industrialism made the old method unprofitable, so that it had practically died out by the turn of the century. Then he attributed its revival to the Great Depression and the resulting unemployment, which had forced the rural people to turn to whatever means of earning a living they could find.

Sander's knowledge of folklore had come from reading and firsthand from his mother's teachings and his experiences as a boy in Herdorf, and he wove it into his work. In his article on farming in the Siegerland he described the ritual that precedes the dance celebrating the end of the labor of clearing away the trees, a ritual known as "the dragging of the woman." One of the young men leaps up, seizes his girlfriend by the legs, and drags her over the newly overgrown field, so that her skirts fly about her. Then all the other girls scream to end the dragging. Only then can the dance begin.

In his book of landscape photographs of the Siebengebirge, Sander devotes most of his introductory text to the geological evolution of the Rhineland. At times he becomes almost poetic describing the events that gave the landscape its present form:

With the advance of the coastal zone, the seething waves… swept forward over the trachytic mountains of the Siebengebirge, and left them behind as islands in the sea. Deeper and deeper the mountains sank down beneath the rising waters…. The smooth surface of the sea spread out above them, and only occasional whirlpools or swirling eddies betrayed the fact that here beneath these waters lay mountains of the future, the loveliest adornments of a landscape yet to come, waiting for the age that would raise them up once again.[30]

It is tantalizing to speculate that Sander's physiognomic approach to the landscape derived in part from his own experience as a miner — laboring deep within the ground whose surface features he read as an expression of inner geological forces. Much later, Josef Hoffmann, a poet in Sander's birthplace, toyed with such speculation. He argued that Sander, like other Siegerlanders, was shaped both physically and psychologically by the miner's life — one that Sander's forebears had experienced for many generations. Hoffmann quoted Walter Vollmer, a miner-poet, who had written: "It is hard to believe how much the mine transforms the inner and outer face of a man, when he must spend a third of his life underground."[31] Hoffmann then added to this, somewhat rapturously, "the solitary, difficult, and dangerous depth, far from the light of the everyday world, near to the eternal, makes this native, this born miner, this miner by blood whose forefathers dug in the earth for thousands of years, into an essential, spiritually deepened individual."[32]

Sander also devoted attention to detailed studies of plants and animals, both intended as scientific documentation. And it was in the mid-Thirties that he began to work back over his archives. He enlarged and cropped old photographs and also took new pictures to create new studies of body parts — hands and feet in particular.

The Nazis now set a close watch over Sander and his

home. When campaigns were mounted against Jewish shopowners to dissuade Germans from doing business with them, Anna Sander was photographed entering one shop. The picture was posted on an advertising column with a scornful denunciation. This incident only made her bolder and more assertive as she continued to patronize Jewish businesses.

With war drawing near, the documentarian in Sander set out to record scenes that he sensed might be lost. He made a special project of Cologne before the bombing, and also of many interiors, including his own studio home.

War broke out September 1, 1939. Sigrid was now living in England; Gunther was called up and later served on the Russian front. From prison, Erich wrote and urged his parents to leave Cologne. Heeding the advice, Sander located and began to restore an old, dilapidated farmhouse in Kuchhausen — a Westerwald village about 55 miles away. He placed 40,000 of his 100,000 numbered negatives in packing cases, and sorted through the eleven rooms of books, artworks, and antiques. Much had to be left behind because of the limited space in the new quarters. With the help of friends, Sander managed gradually to move his photographic equipment and belongings. When the bombs started falling on Cologne, he and Anna left for the country. Just before they left, the Cologne house was hit, but Sander managed to save it by cutting away burning pieces of timber with an ax.

During the war years, Sander and his wife remained in Kuchhausen, generally safe from the bombs. Sander continued to produce industrial and advertising photographs, and to work on his landscapes. Curiously, even these might have drawn Nazi ire. In a 1976 German television program marking the centennial of Sander's birth, Herbert Molderings, a German art historian, pointed out that even landscape photography was dangerous during the Nazi era.[33] The Nazis wanted only photographs emphasizing German ties to the soil, and it was dangerously easy for photographers to slip into this sort of propaganda photography without realizing what they were doing.

Despite the wartime hardships, Sander managed to imprint his own aesthetics on the Kuchhausen farmhouse. He filled the rooms with color and converted a pigsty into a heated bathroom complete with running water that poured from faucets shaped like fish. Always able to get along well with Westerwald villagers, Sander even persuaded his neighbors to move their unsightly dung heaps from the front of their houses to the rear. He also paid for and placed a bench under one stately walnut tree whose owner was planning to chop it down.

There were frequent exposures to danger. Sander sheltered some Jews in his home, and visited others who were under house arrest to take them food. Under constant Nazi surveillance, Sander's irascible nature often got him

into trouble. He got into one dispute with a uniformed Nazi official on a Cologne streetcar. Sander punched the man in the face and calmly got off at his stop, leaving behind a group of awestruck passengers. On another occasion, a

New Year's card 1947

salesman for a Nazi journal stopped by Sander's home and tried to persuade him to buy a subscription. Sander kicked the man down the stairs and threw him out of the house. This prompted a grave warning from the Nazi district leader. Almost every week, Sander was picked up by *der blaue Wagen* — the blue van, or Nazi paddy wagon — for questioning. He was also brought to court, but escaped punishment.

Anna was nearly killed on a trip to Cologne. She had returned to the family's home to look for useful household items, and caught the last train back to Kuchhausen after finding a favorite cast-iron frying pan. The train, loaded with hundreds of passengers, was attacked by dive bombers not far from the village. Anna crouched in the car and placed the frying pan over her head. The slaughter was terrible: the man beside her was decapitated, and she was covered with his blood and brains. Meanwhile, in the village, the alarm had sounded and word spread concerning the attack. For the first time in his life, Sander almost went to pieces. With most of the villagers accompanying him, and a horse-drawn wagon brought by one neighbor, he went out to meet the train. Along the tracks they saw Anna walking toward them, covered with blood. She collapsed as she reached the group, but she was unharmed and they brought her home in the wagon. She was one of only eight survivors among the hundreds who had boarded the train in Cologne.

The worst tragedy of Sander's life occurred just before the end of the war. Only eight months remained of Erich's long

sentence in the prison where he first worked as a hospital attendant and later as a photographer. One day his appendix ruptured and, although he was doubled up in pain, the SS officer in charge accused him of faking. Finally, he was given morphine to quiet his screams, but the Nazi officer refused to send him to the hospital until it was too late to save his life. Erich died March 23, 1944.

Finally, the war ended, yet one final horror remained. The negatives stored in the Cologne basement miraculously had survived the air raids, although the house itself had been destroyed. Then, in 1946, a fire started by looters reached the cellar and the negatives were consumed. Soon after, Sander wrote to Sigrid: "This is the bitterest blow that has struck me in my work. A writer can write, an artist can draw, but a photographer is shot dead when his subjects are no longer alive and his negatives are destroyed."[34]

Despite his grief, Sander plunged into work once more. Gunther, who had made his way back from Russia and had surrendered to the Americans, was released. In 1946, he arranged with West-German Radio to broadcast an interview with his father.

Sander was acutely aware of the need to rebuild and to revitalize the art and culture of his country. In those first hard years after the war he sent striking New Year's cards to friends in Germany and throughout the world. Usually, his cards were photomontages — a technique picked up from the Dadaists, which Sander had found most useful in his advertising photography. One card from the terrible winter of 1946-1947 contained the following verses by "H.M.":

> O glowing life,
> you have been transformed
> to deepest grief....
>
> Already darkness threatens,
> abyss,
> eternal blackness....
>
> But on your brow
> Still burns the spark,
> the eternal begetting....
>
> You have conquered death.[35]

Beside the verse is a photomontage: a view from a mountaintop out over mountains and valleys covered with clouds and haze. In the sky, which takes up half the picture, there is a huge black sphere, with a radiance emerging from its edges, like the sun in eclipse, or like a black void cut in the firmament.

If there is a literary equivalent that evokes a similar response, it might be "The Speech of the Dead Christ ... Proclaiming That There Is No God," in Jean Paul's work, *Siebenkäs* published in 1796. In one searing lament, the dead Christ calls out:

I peered into the abyss and cried, "Father, where are you?" But I heard only the eternal storm, ruled by no one...and as I looked into the immeasurable universe for the eye of God, it stared at me with an empty, bottomless eye socket.[36]

Other photomontages from those years repeatedly show the silhouette of a photographer looking out over a sea of rubble and ruin. A few years later, still intensely concerned with the spiritual rebirth of Germany, Sander chose an accompanying quote from Friedrich Hölderlin, who had written it a century and a half before:

O when, creative spirit of our nation, O when shall you appear completely, soul of the fatherland, so that I may bow more deeply, so that my softest lute string will grow silent before you, so that I – ashamed and still – a flower of night, may end my days with joy before you, O heavenly day, when all of those, with whom in times gone past I grieved, when all the towns and cities are awake and bright and open, filled with purer fire, and the mountains of Germany are the mountains of the Muses.[37]

In 1949, Sigrid, who had gone to Iceland from England to live during the war and had recently settled in the United States, journeyed home for a month-long visit. It was a joyous reunion, but tinged with sadness. She had lost track of her family at the outset of the fighting and had not heard anything since. A letter from the Icelandic Red Cross finally brought the news that they were alive and well — except for Erich — and Sigrid made immediate plans for the visit.

The same year, after remodeling his Kuchhausen studio, Sander began to photograph people again and continued with his landscapes. An ambitious program of work was laid out, books and portfolios that were to include *Flora of the Rhine; The City of Cologne As It Was; Rhineland Architecture from the Time of Goethe to Our Day; Organic and Inorganic Tools of Man*, including human body parts and prosthetic devices; *Cologne Painters of Today: Types and Reproductions of their Work 1920–1933*, assembled from his many pictures of the Cologne artists and their paintings; *Man and Landscape*; and series on his own studio, to be accompanied by writings on photography. The Cologne pictures were now of tremendous historic value because, as Sander had correctly anticipated, the old city had been virtually erased from the earth. He subsequently sold his collection of these photographs to the city for 25,000 marks.

One of the most moving experiences of Sander's life occurred not long afterward. Edward Steichen, curator of photography at New York's Museum of Modern Art, was in Europe to acquire pictures for "The Family of Man" exhibition. L. Fritz Gruber, director of the Photokina exhibition of 1951, where Sander's work had been displayed, suggested that Steichen pay a visit to Kuchhausen. The two

old men were deeply moved when they met and embraced. As far back as 1908, they had been exhibiting together and winning prizes in the same show.

In 1957, Anna, Sander's wife of fifty-five years died. Her last words were an apology that she was leaving him alone, that she would not be by his side during the final years.

After Anna's death, Sander was quite lonely. He was no longer strong enough to complete his life's project, although he continued to work over his archives. Nor could he continue venturing out into the Westerwald on the motorcycle that had replaced his battered bicycle. In 1958, he was honored at a celebration in Herdorf, where a street was named for him. The women of Kuchhausen continued to care for his needs. But there was simply no one for Sander to talk to. His friends, the artists, writers, clergymen with whom he had engaged in such lively exchanges years before, were either dead or scattered widely throughout the world.

Sander lived his final years in solitude, but away from Kuchhausen his fame was spreading. Manuel Gasser, the distinguished editor of the Swiss magazine *du* had come across an old copy of *Face of Our Time*. Through the German Photographic Society he tracked Sander to Kuchhausen, and in November 1959, *du* published a special edition devoted to his work. The issue sold out within a month. In 1960, Sander was awarded the Federal Order of Merit, and the following year — perhaps the crowning glory of his career — the Cultural Prize of the German Photographic Society. Around the world, numerous exhibitions of his work were launched, and in 1962, a new collection of his portraits was published in a book entitled *Deutschenspiegel (Mirror of Germans)*.

In December 1963, Sander suffered a stroke. On April 20, 1964, he died at the age of eighty-eight.

— ROBERT KRAMER

1. August Sander, Introductory Brochure for *Antlitz der Zeit (Face of Our Time)* (Munich: Kurt Wolff/Transmare, 1929).

2. Letter from Thomas Mann to Kurt Wolff, Jan. 6, 1930. Private collection.

3. *Pester Lloyd* (Budapest, c. 1929), unsigned review. Private collection.

4. Quoted in Bill Kinser and Neil Kleinmann, *The Dream That Was No More a Dream, 1890-1945* (New York: Harper and Row, 1969), p. 34.

5. Quoted in Werner Doede, *Berlin Kunst und Künstler Seit 1870 (Berlin Art and Artists since 1870)* (Recklinghausen: 1961), p. 180.

6. Ibid.

7. August Sander, "Meine erste Begegnung mit der Landschaft" ("My First Encounter with Landscape"). Private collection.

8. August Sander, "Wildgemüse" ("Wild Plants"), *Velhagen und Klasings Monatshefte* (June 1937), p. 361.

9. August Sander, "Meine erste Begegnung mit der Landschaft."

10. August Sander, "Mein Werdegang als Photograph" ("My Development as a Photographer"), n.d. Private collection.

11. Ibid.

12. Ibid.

13. August Sander, *The Nature and Development of Photography*, Lecture 3.

14. Quoted in August Sander, Advertising Brochure, c. 1910. Private collection.

15. Ibid.

16. Alfred Döblin, Introduction to August Sander, *Antlitz der Zeit*, p. 7.

17. Quoted in August Sander's New Year's card, 1957, translated by Walter Kaufmann. Private collection.

18. Letter from August Sander to an uncle, Dec. 26, 1929. Private collection.

19. Quoted in Kurt F. Reinhardt, *Germany: 2,000 Years*, Vol. 2, (New York: Ungar, 1962), p. 579.

20. Ulrich Finke, *German Painting from Romanticism to Expressionism* (Boulder, Colo.: 1975), p. 150.

21. August Sander, Introduction to the exhibit of his photographs at the Cologne Art Association (Nov. 1927). Private collection.

22. Letter from August Sander to an uncle, Dec. 26, 1929. Private collection.

23. Letter from August Sander to Sigrid Sander, c. 1946. Private collection.

24. Paul Bourfeind, "*Menschen des 20. Jahrhunderts*" ("Man of the Twentieth Century"), *Rheinische Blätter für Kulturpolitik* (Jan. 1928).

25. Walter Benjamin, "*Kleine Geschichte der Photographie*" ("Brief History of Photography"), *Die literarische Welt*, (Oct. 2, 1931). p. 7.

26. August Sander, *The Nature and Development of Photography*, Lecture 3.

27. Ibid. Lecture 5.

28. Ibid.

29. Ibid.

30. August Sander, *Das Siebengebirge: Deutsches Land, Deutsches Volk (The Siebengebirge: German Land, German People)*, (Rothenfelde: Holzwarth, 1934).

31. Josef Hoffmann, "*Sohn der Väter und der Heimat*" ("Son of His Fathers and of His Homeland"), reading at opening of Sander exhibit at Herdorf, April 30, 1958. Private collection.

32. Ibid.

33. Herbert Moldering, Radio Free Berlin television discussion of August Sander (Jan. 21, 1976).

34. Letter from August Sander to Sigrid Sander, c. 1946. Private collection.

35. Quoted in August Sander's New Year's card, 1947. Private collection.

36. Jean-Paul (pseud. for Jean-Paul Friedrich Richter), *Jean-Paul, Werk – Leben – Wirkung (Jean-Paul – Works – Life – Influence)*, (Munich, 1961) p. 173.

37. Quoted in August Sander's New Year's card, 1951. Private collection.

CREDITS

Book of Trades by Jost Amman and Hans Sachs, (1568), p. 19; *The Dance of Death* by Hans Holbein the younger (1538), p. 19; Staatliche Museen Preussischer Kulturbesitz, Nationalgalerie, Berlin, p. 31; Gemäldegalerie, Dresden, p. 31; *Die neue Sachlichkeit in Deutschland*, by Emilio Bertonati, (Milan: Fratelli Fabbri Editori, 1969), p. 31; Galleria del Levante, Milan: p. 31; Ch. Grossimlinghaus, Cologne: p. 32.

PHOTOGRAPHS

MAN OF THE TWENTIETH CENTURY

More than anything else, physiognomy means an understanding of human nature. . . . We know that people are formed by light and air, their inherited traits, and their actions, and we recognize people and distinguish one from another by their appearance. We can tell from appearance the work someone does or does not do; we can read in his face whether he is happy or troubled, for life unavoidably leaves its trace there. A well-known poem says that every person's story is written plainly on his face, though not everyone can read it. These are runes of a new, but also ancient, language. . . .

The individual does not make the history of his time, he both impresses himself on it and expresses its meaning. It is possible to record the historical physiognomic image of a whole generation and, with enough knowledge of physiognomy, to make that image speak in photographs. This historical image will become even clearer if we juxtapose pictures typical of the many different groups that make up human society, which together would carry the expression of the time and the sentiments of their group. The time and the group sentiment will be especially evident in certain individuals whom we can designate by the term "type." The same observations can be made about sports clubs, musicians, businesses, and similar organizations. Thus the photographer with his camera can grasp the physiognomic image of his time.

August Sander, *The Nature and Development of Photography*, Lecture 5, 1931

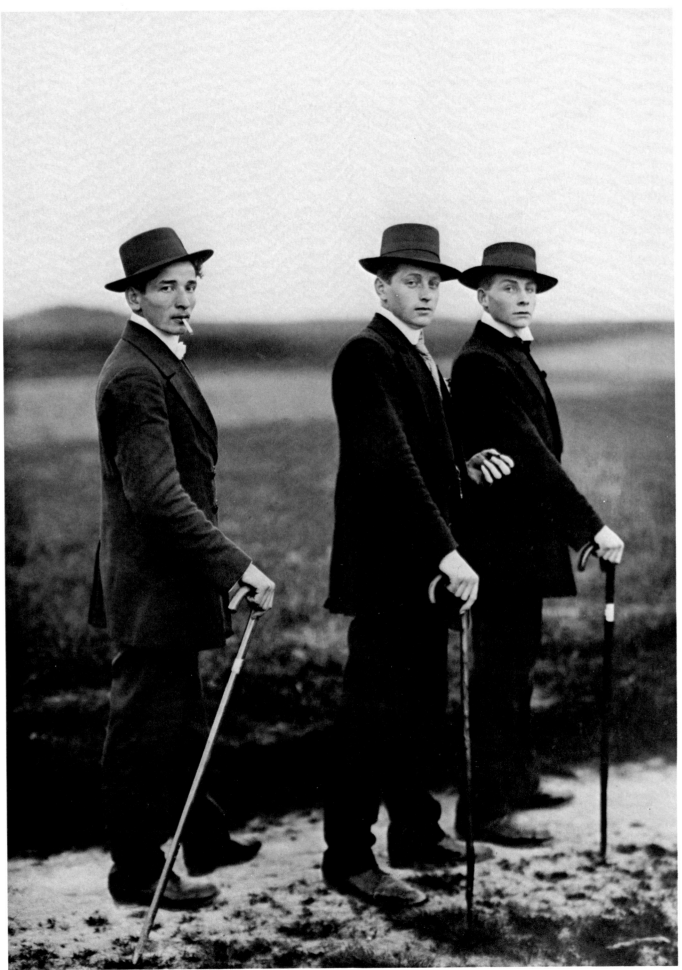

Farm Youths Young farmers on way to a dance, Westerwald 1914

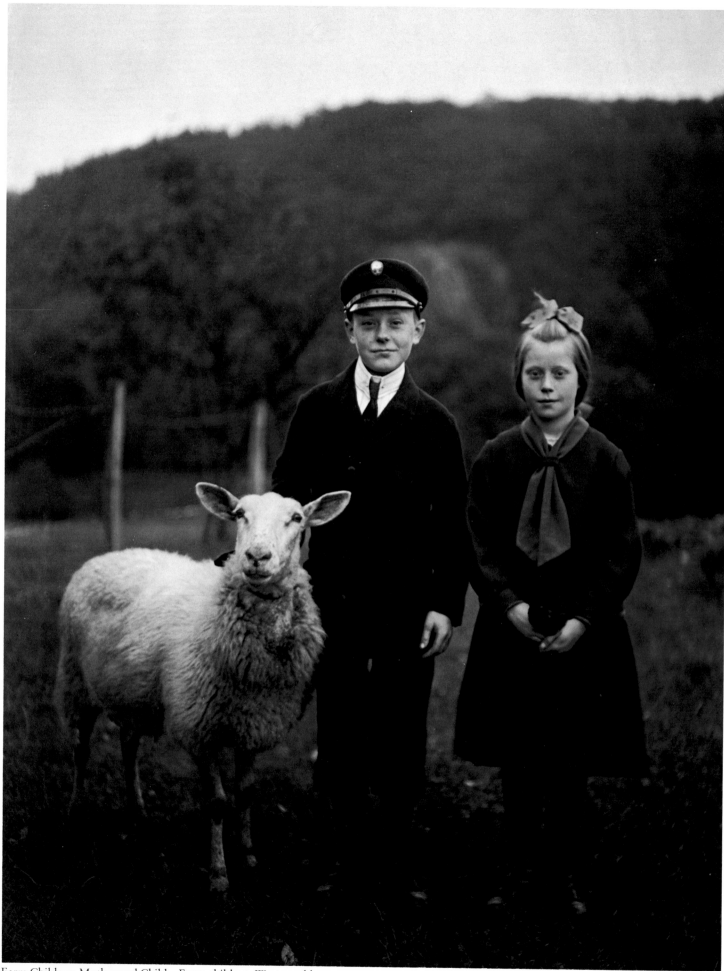

Farm Children; Mother and Child Farm children, Westerwald c. 1924

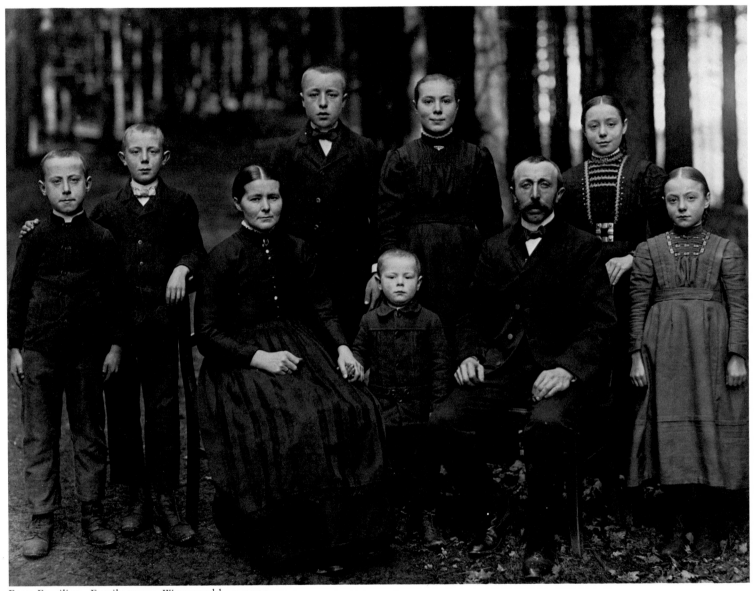

Farm Families Family group, Westerwald c. 1914

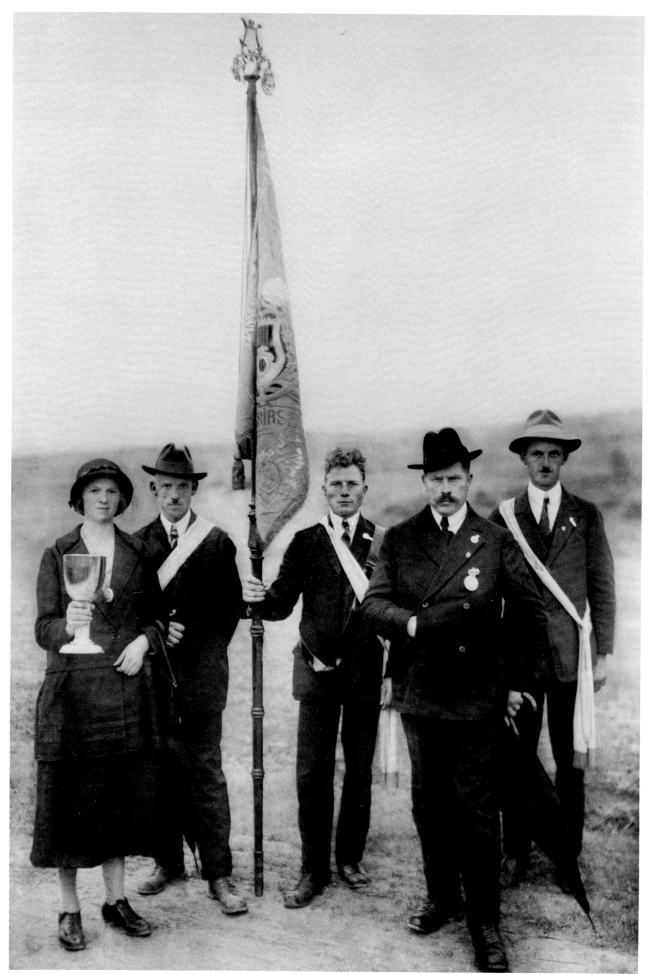

Farm Life Prizewinning choral club, Westerwald 1927

Farm Life Farmer on way to a funeral, Westerwald 1925

Farmers Landowner and wife, Cologne c. 1925

Small-Town People Couple, Monschau 1928

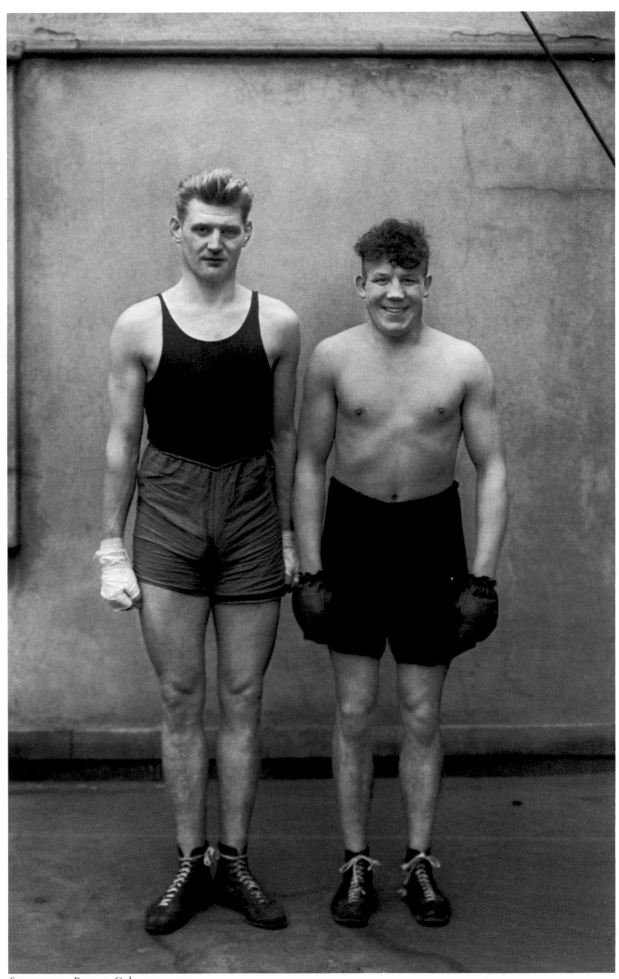

Sportsmen Boxers, Cologne 1929

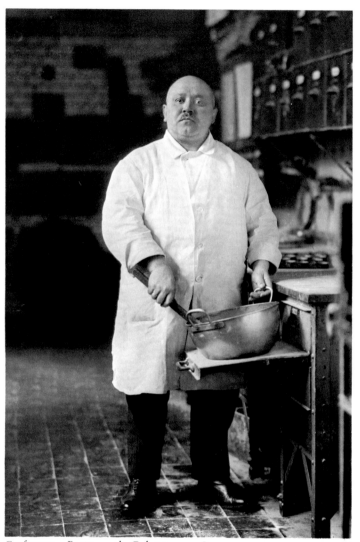

Craftsmen Pastry cook, Cologne 1928

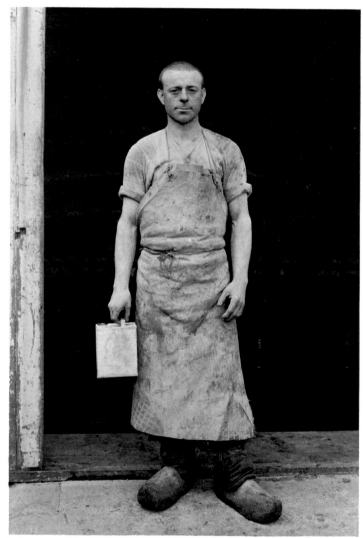

Laborers Varnisher, Cologne 1932

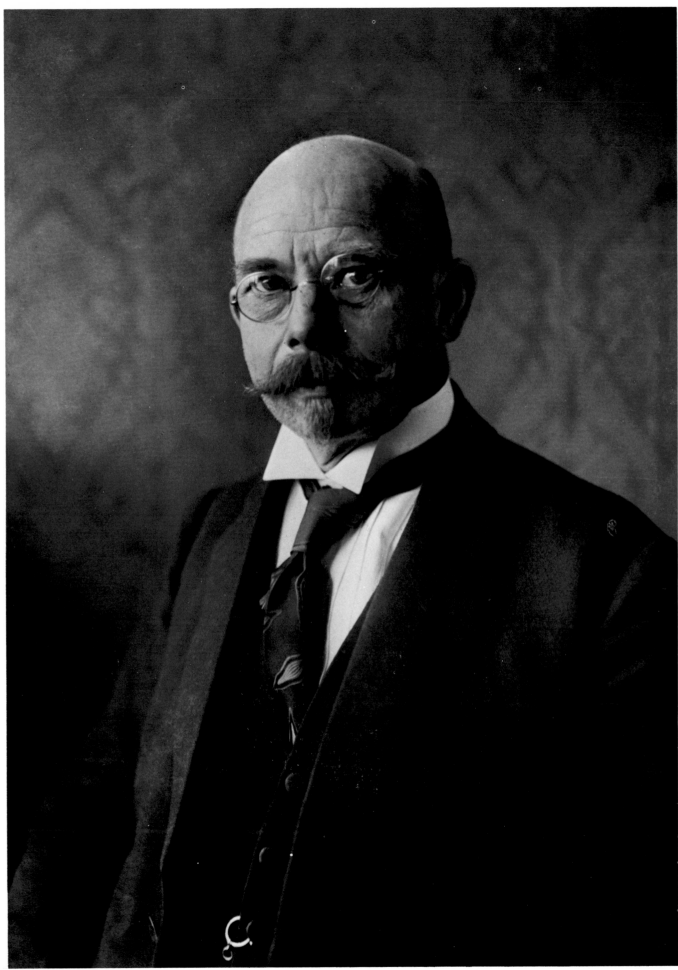

Industrialists, Cologne 1925

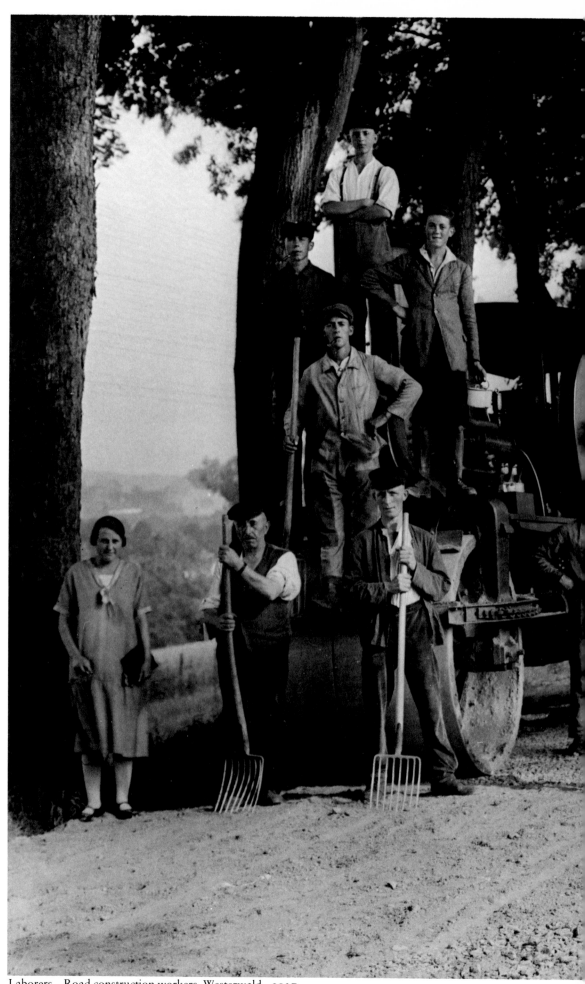

Laborers Road construction workers, Westerwald 1927

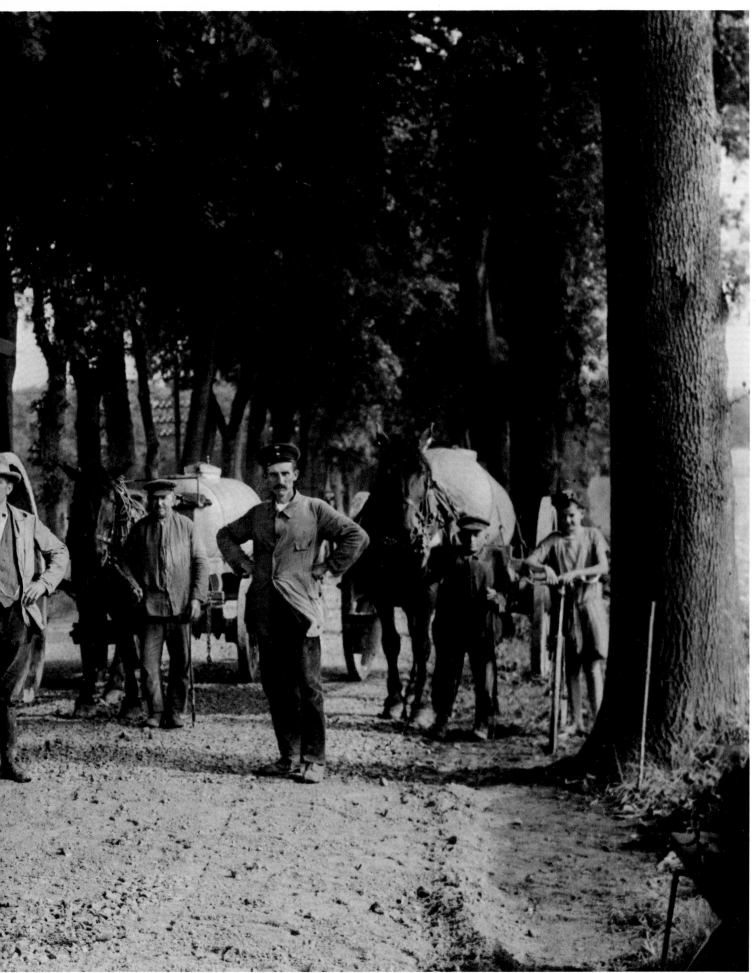

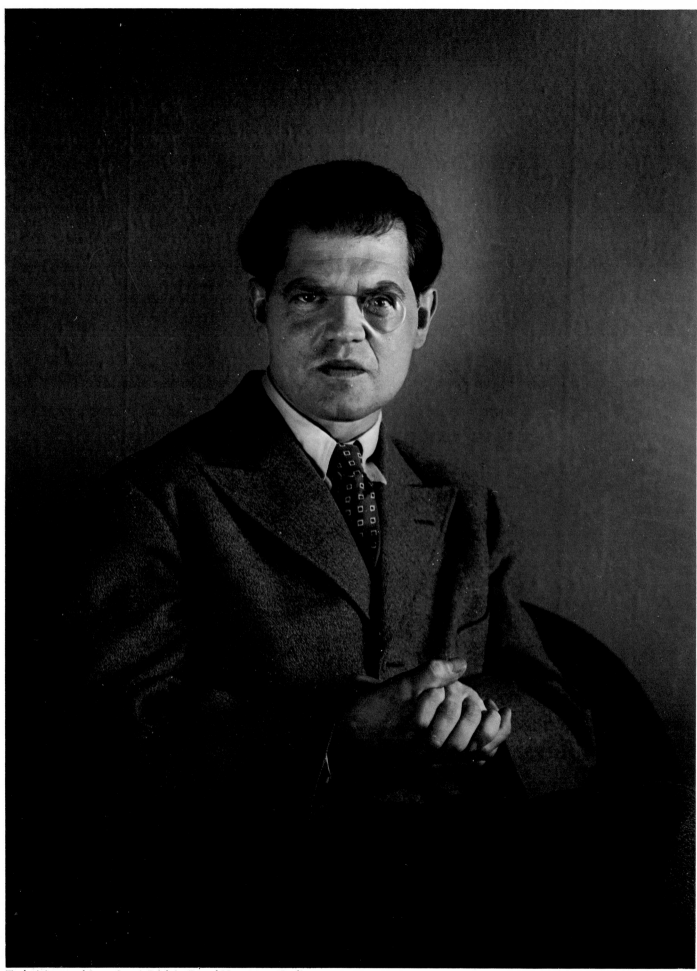

Technicians and Inventors Dadaist Raoul Hausmann, Berlin 1929

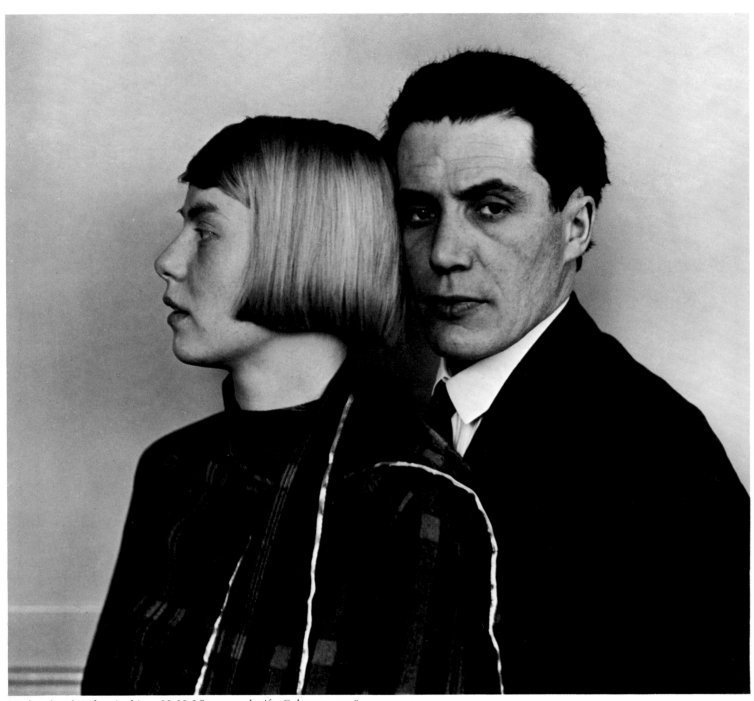

Husband and Wife Architect H. H. Lüttgen and wife, Cologne 1928

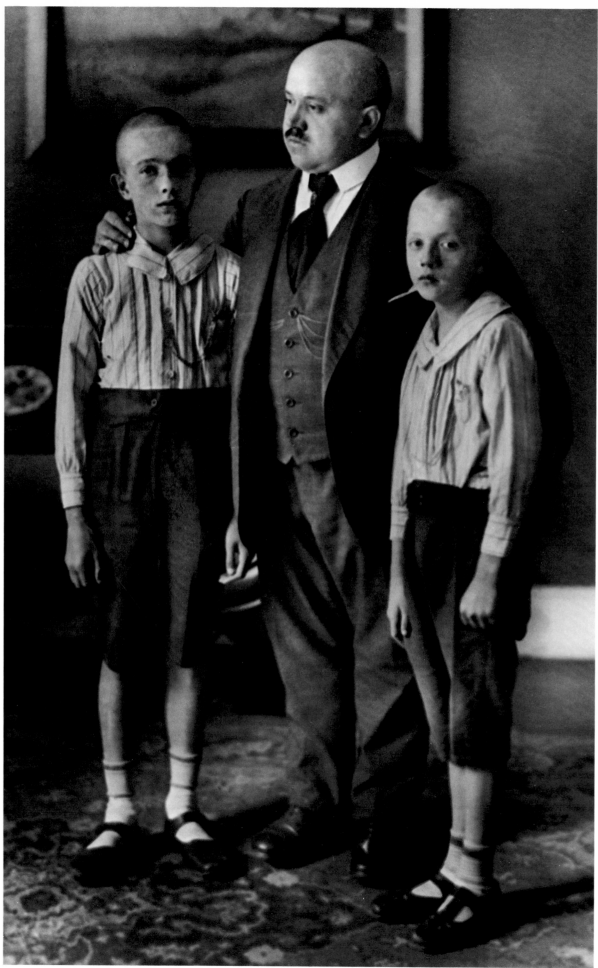

Families Widower and sons, Cologne 1919

Women and Children Dr. Lu Strauss-Ernst and son Jimmy, Cologne 1928

Professional Women Shorthand typist, Cologne 1928

Society Women Wife of painter Peter Abelen, Cologne 1926

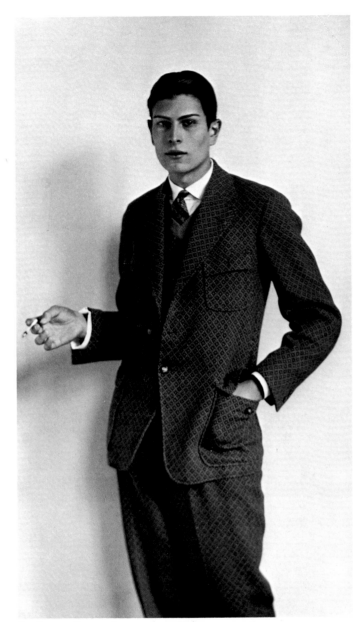

Students Gymnasium student, Cologne 1926

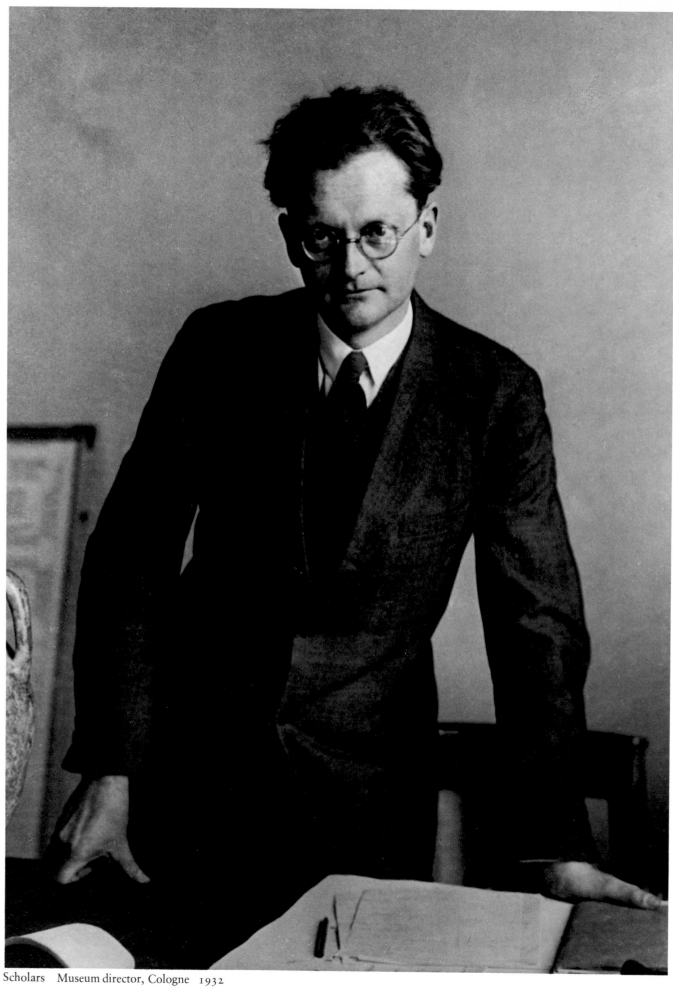

Scholars Museum director, Cologne 1932

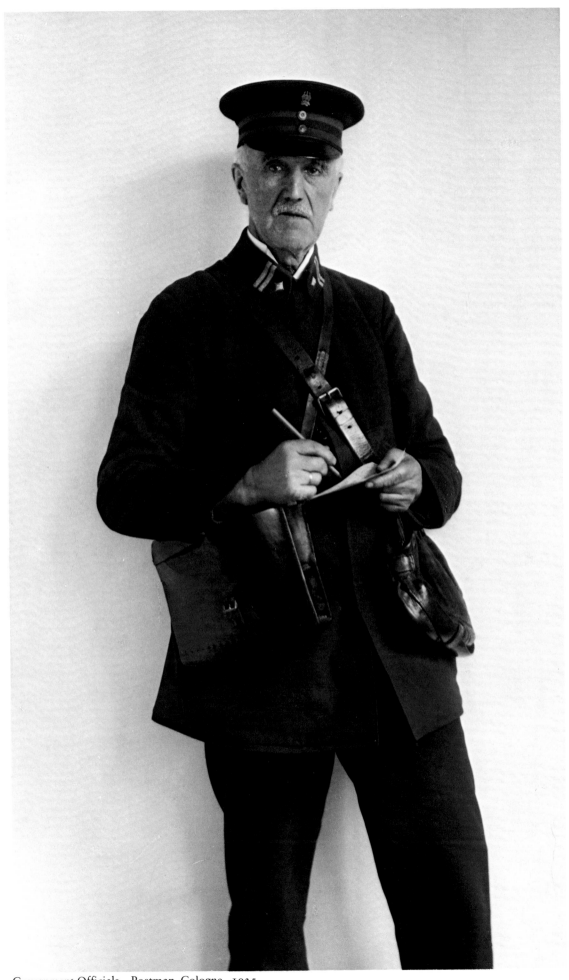

Government Officials Postman, Cologne 1925

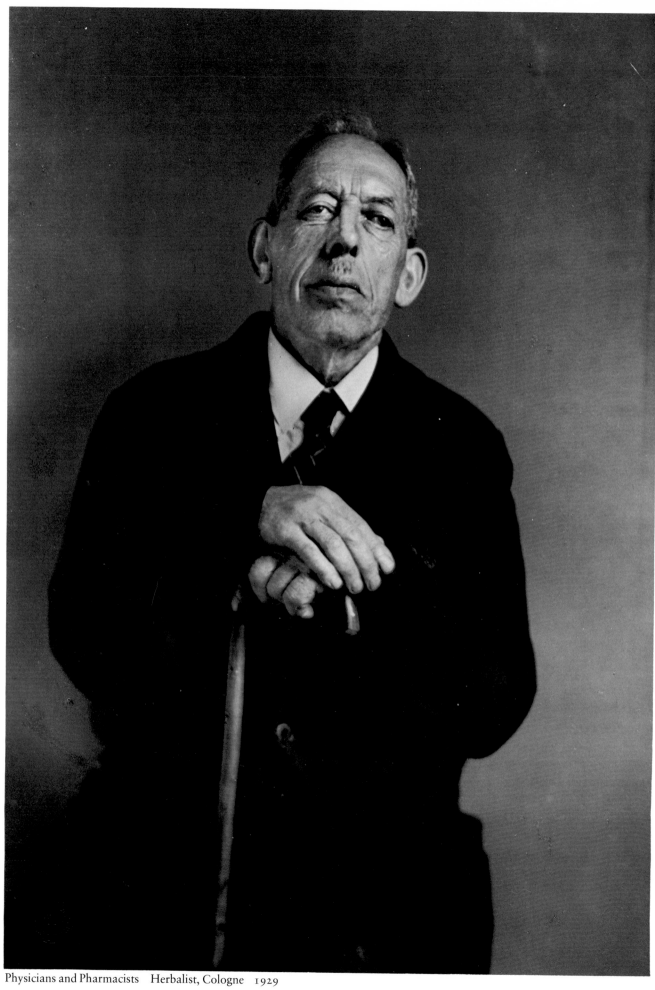

Physicians and Pharmacists Herbalist, Cologne 1929

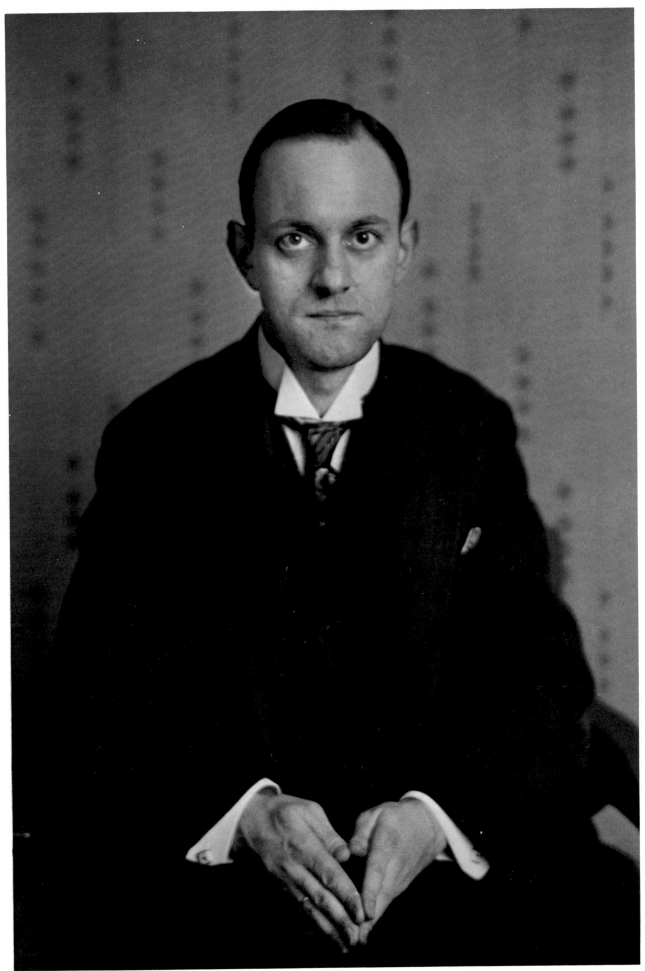

Judges and Lawyers Public prosecutor, Cologne 1931

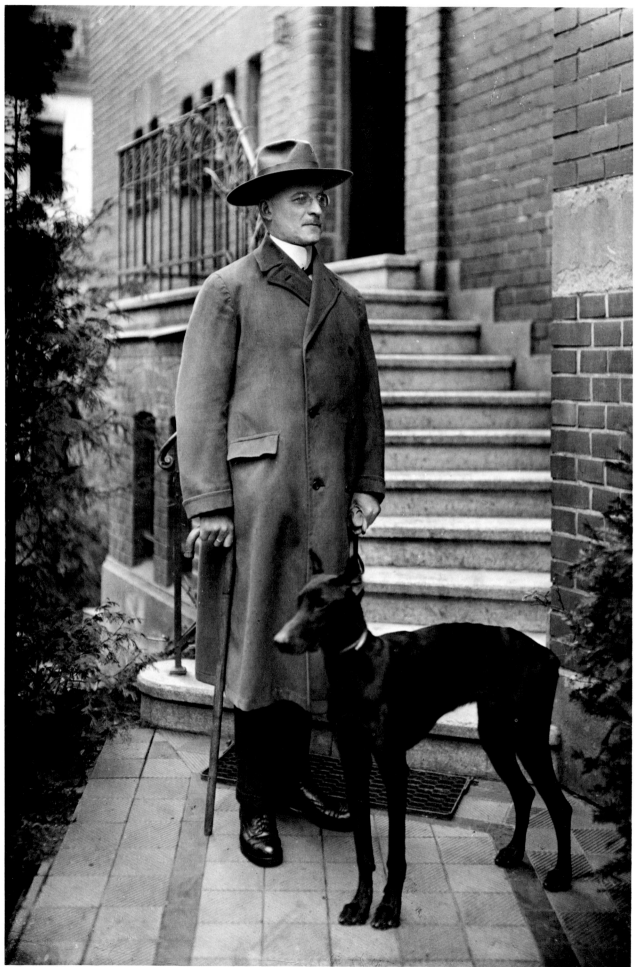

Judges and Lawyers Notary, Cologne 1924

Soldiers Young soldier, Westerwald 1945

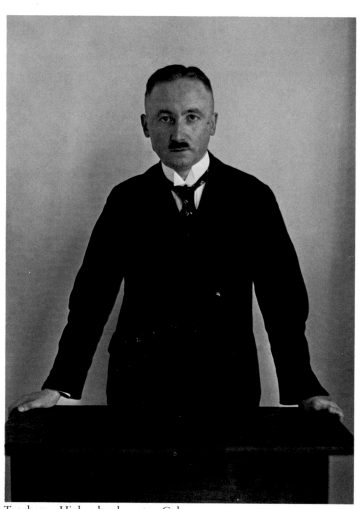

Teachers High-school master, Cologne 1932

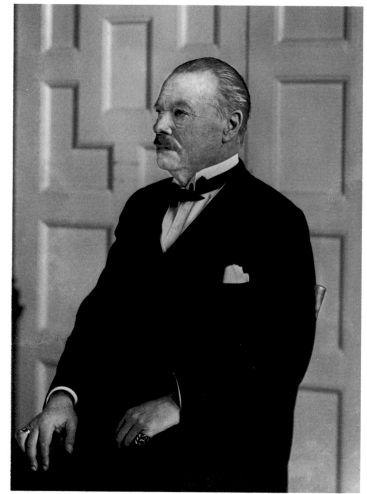

Artistocrats Grand Duke of Hessen-Nassau, Darmstadt 1928

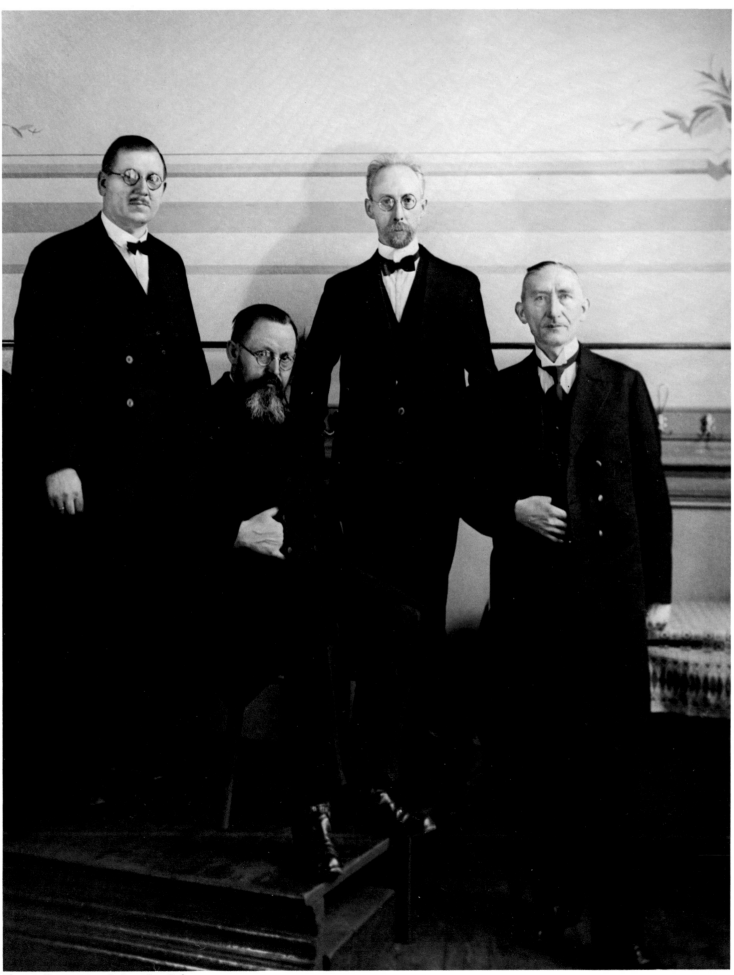

Clergy Protestant missionaries, Cologne 1931

Businessmen Banker, Cologne 1932

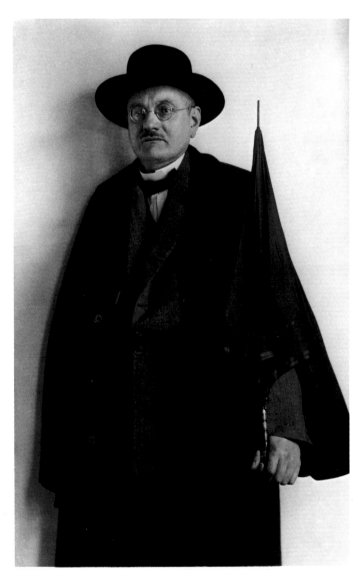

Actors Unemployed touring actor, Cologne 1930

Politicians Social Democratic parliamentarian, Cologne 1927

67

Writers Writer and editor Otto Brüs, Cologne 1928

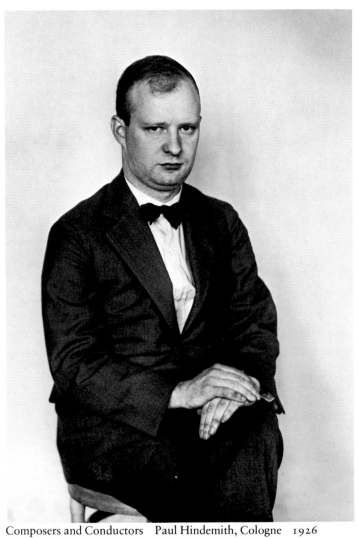

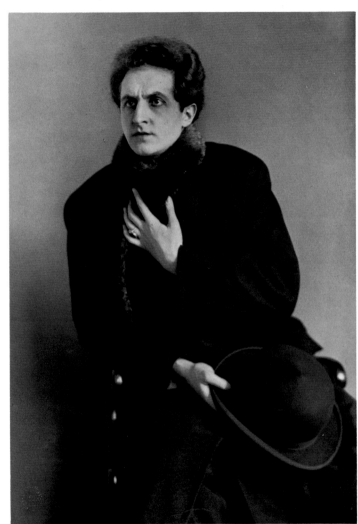

Composers and Conductors Paul Hindemith, Cologne 1926

Musicians Leonardo Aramesco, Cologne 1931

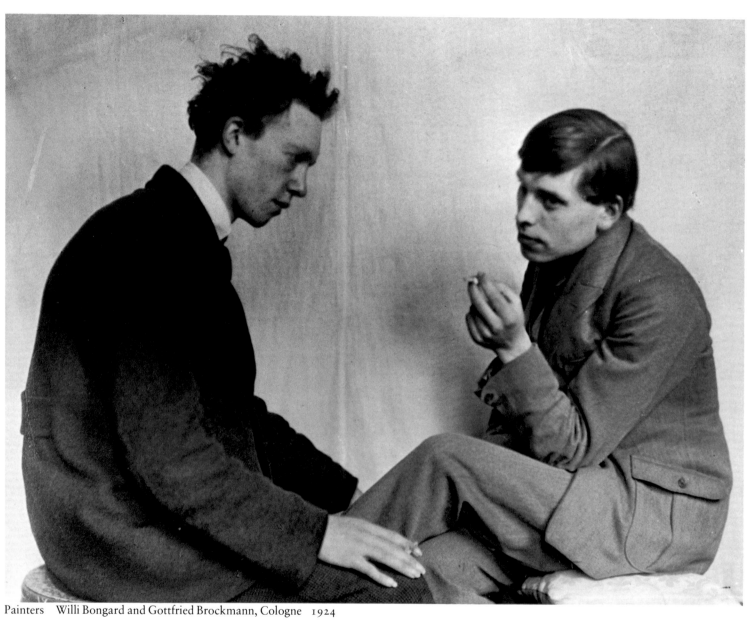

Painters Willi Bongard and Gottfried Brockmann, Cologne 1924

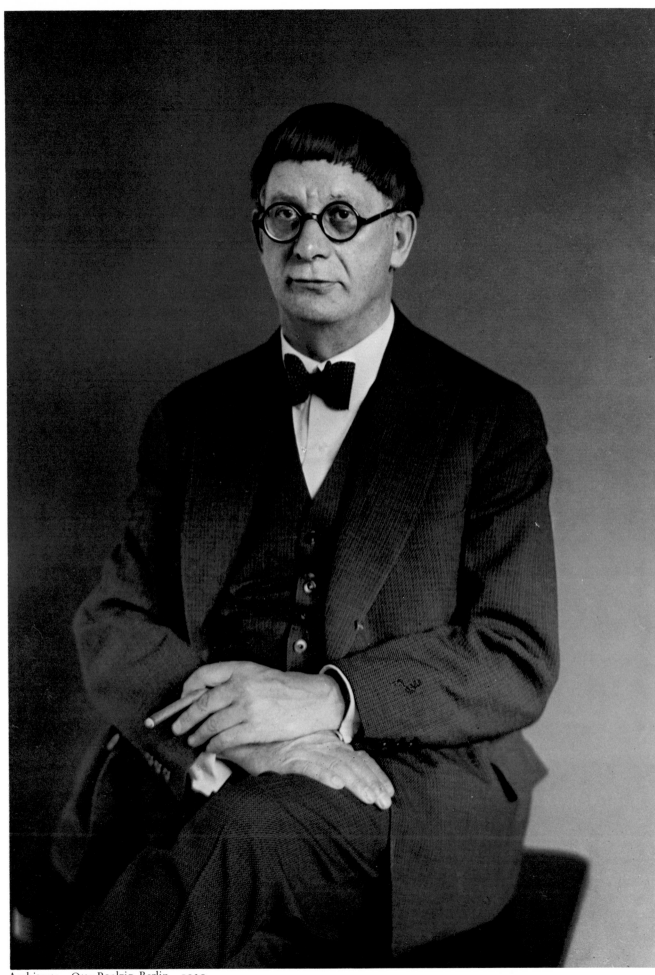

Architects Otto Poelzig, Berlin 1929

When someone is trying to be natural, or better, when he does not know he is being photographed, he reveals character. But if he approaches the camera with a certain solemnity, with the intent of showing himself off, he has become something more than himself: he is revealing a secret self-image. There is no movement, no laughter, only deadly seriousness and the desire to be taken seriously by others. Then the type is created, and it is types that the creator of these portraits set out to record.

Golo Mann, introduction, *Men without Masks*, 1971

Painters Anton Räderscheid, Cologne 1926

Gypsies and Hobos Gypsy, Westerwald c. 1932

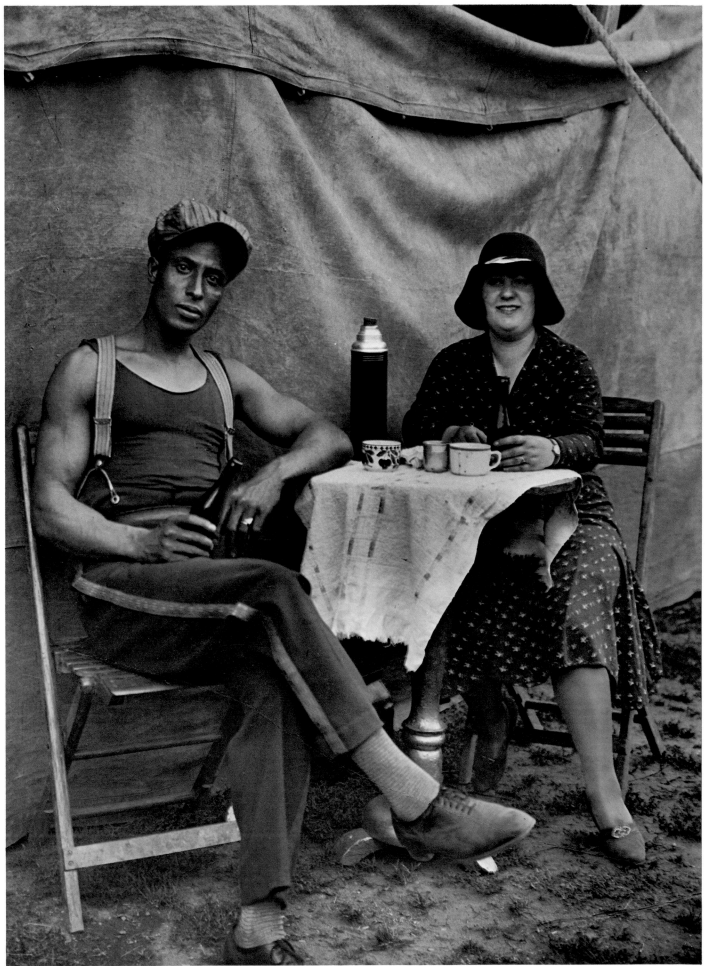

Fair and Circus People Circus workers, Düren 1930

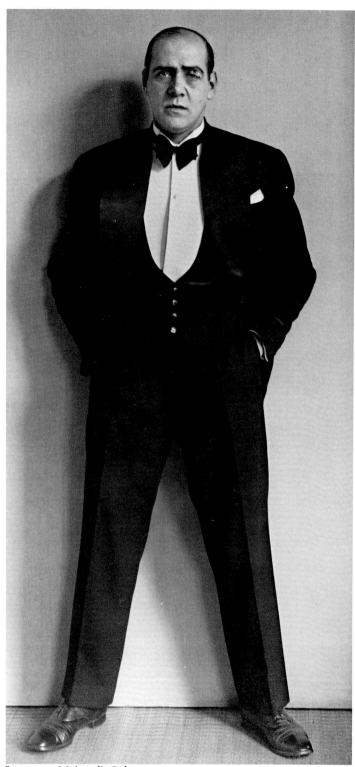

Servants Maitre d', Cologne 1930

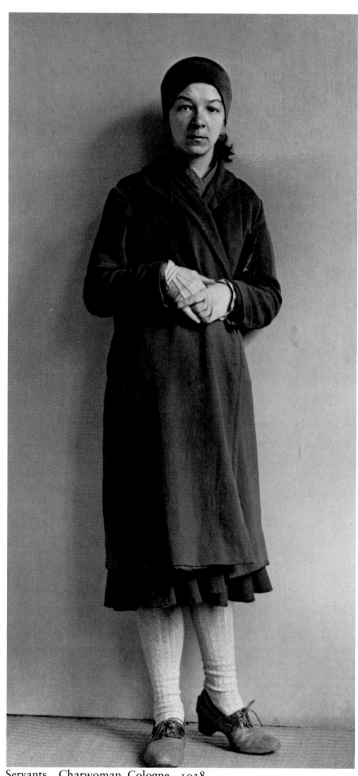

Servants Charwoman, Cologne 1928

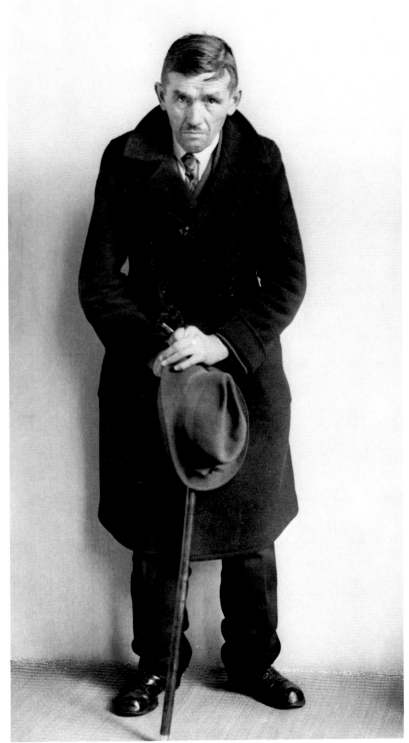

Urban Images Welfare recipient, Cologne 1930

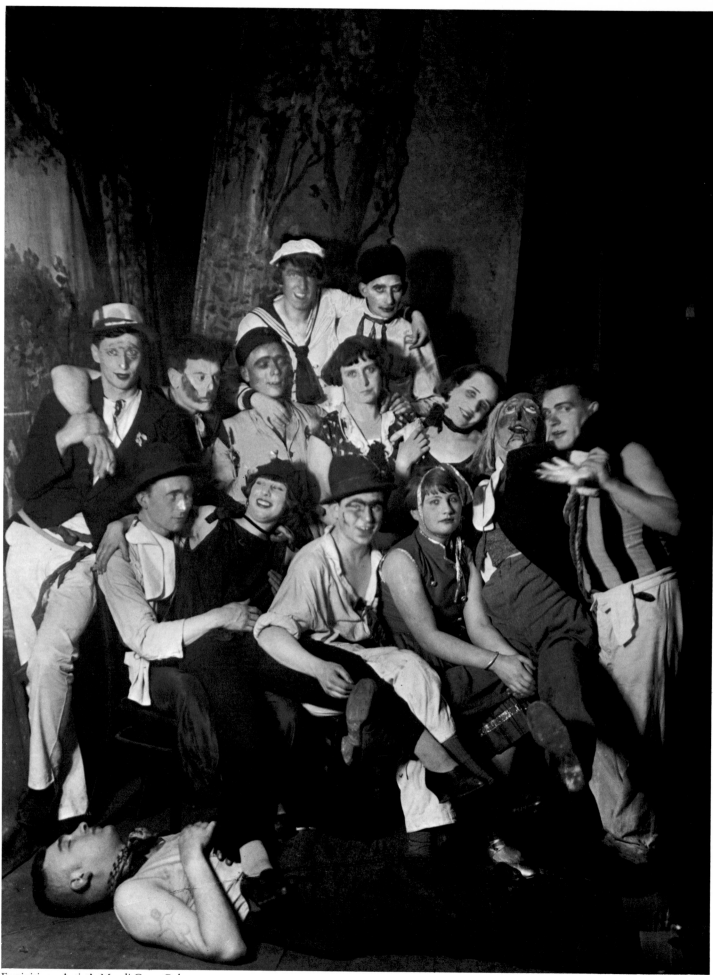

Festivities Artist's Mardi Gras, Cologne 1929

City Youths Working-class children, Cologne 1927

Ill, Insane, and Disabled Children in home for the blind, Düren 1930

Urban Images Unemployed man, Cologne 1928

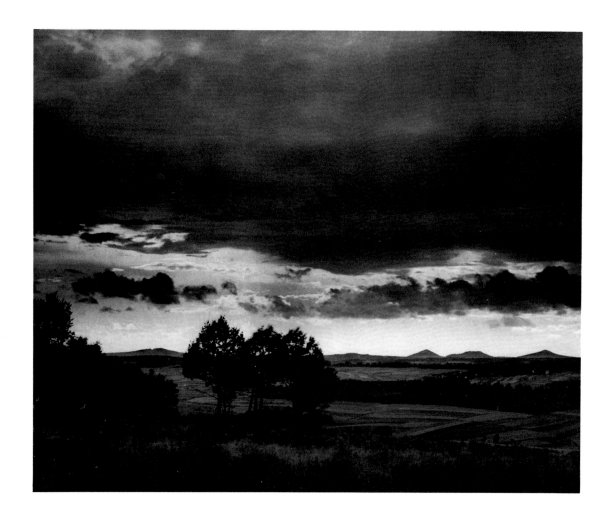

RHINELAND LANDSCAPES

My first encounter with landscape was in Herdorf, in the Siegerland – in the valley of the Sottersbach, to be precise. I was born and passed my youth there, and my parents' house stands there to this day. The valley is narrow and lovely, enclosed by richly wooded mountains, and the brook meanders in many twists and turns. With every season the splendid landscape changes its colors. The fish sport in the brook, and the trout especially play their lively games; I never tired of watching the fish in the whirling waters. The Sottersbach provides them with excellent living conditions, with its banks overgrown with bushes and reeds, and its many hiding places. Here, too, the songbirds find favorable living conditions, and at an early age I learned to recognize the different species.

On the opposite slope of the mountain, to our great joy, a little locomotive from the 1870s groaned and panted in all possible and impossible tones. Several times a day it

pushed heavily laden coal cars up the valley to a mine, and carried down iron and iron ore that the miners at the upper end of the valley had brought to the surface.

Every day in spring at eight o'clock in the morning the village herdsman came to drive the cattle with their splendid bells to pasture. There were at least two hundred cows, and it always took a long time for the herd to pass our house. There were many young, very high-spirited cows, which gave the whole scene a merry air. The herdsman was always accompanied by two shepherd dogs. At noontime the herd was penned in and rested while the dogs watched over the cows. The herdsman ate his lunch in front of his hut behind the Kunzig Forest, near the mine called Accidental Good Luck. Each day the children of a different house were responsible for taking food to the herdsman. As soon as he had eaten his fill, he was content and began to tell strange tales – time and again he was able to bring alive the dark forest and its clearings.

He was an excellent botanist, who knew all the names of the flowers and their meanings, but he was feared by some of the peasants because he not only knew every plant but every animal and in whose stall it belonged. If he was not given a decent meal, he took vengeance by feeding the animals a plant that would keep them from giving more milk. He also knew the antidotes that would enable the cows to give milk again, and because of this, he gained a reputation among the peasants as a wizard. This didn't bother us at all; we were glad to be in his presence because he knew how to tell tales so well.

This good man intensified not only our childish thirst for knowledge, but our fear of the forest, especially when it got dark. In the twilight when the full moon began to pour out its mild light over the landscape, when the animals and the forest were silhouetted against the sky, and when the forest grew gloomier and more sinister, we children would sit down close together and fantasize about ghosts and spirits.

August Sander, *The Nature and Development of Photography*, Lecture 2, 1931

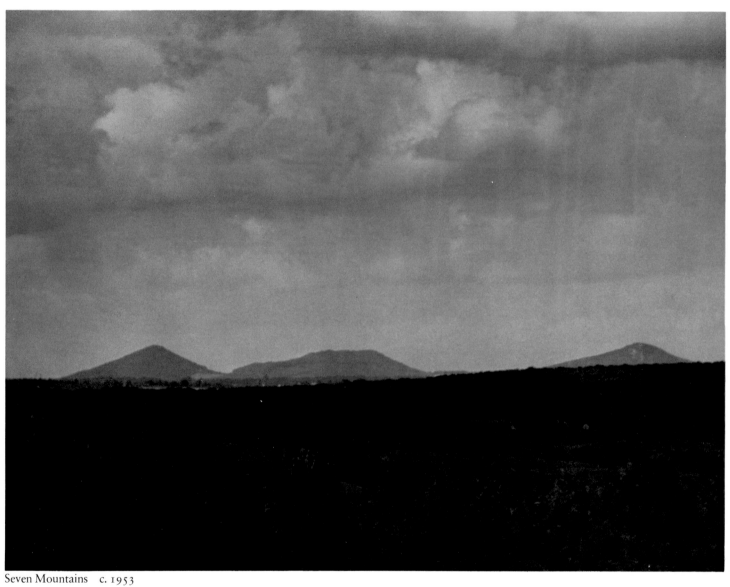

Seven Mountains c. 1953

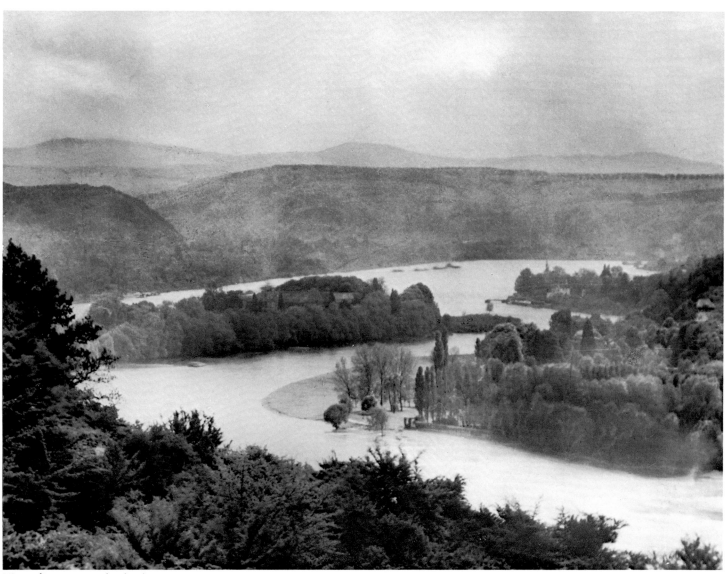

View of Nonnenwerth Island 1937

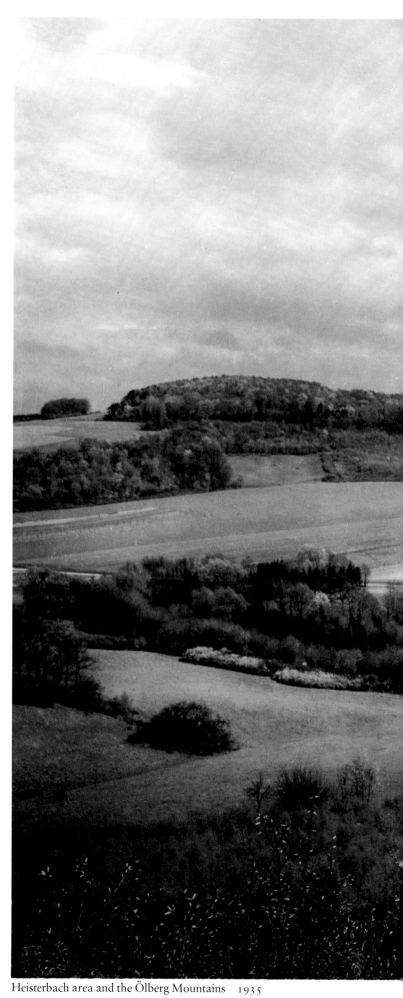

Heisterbach area and the Ölberg Mountains 1935

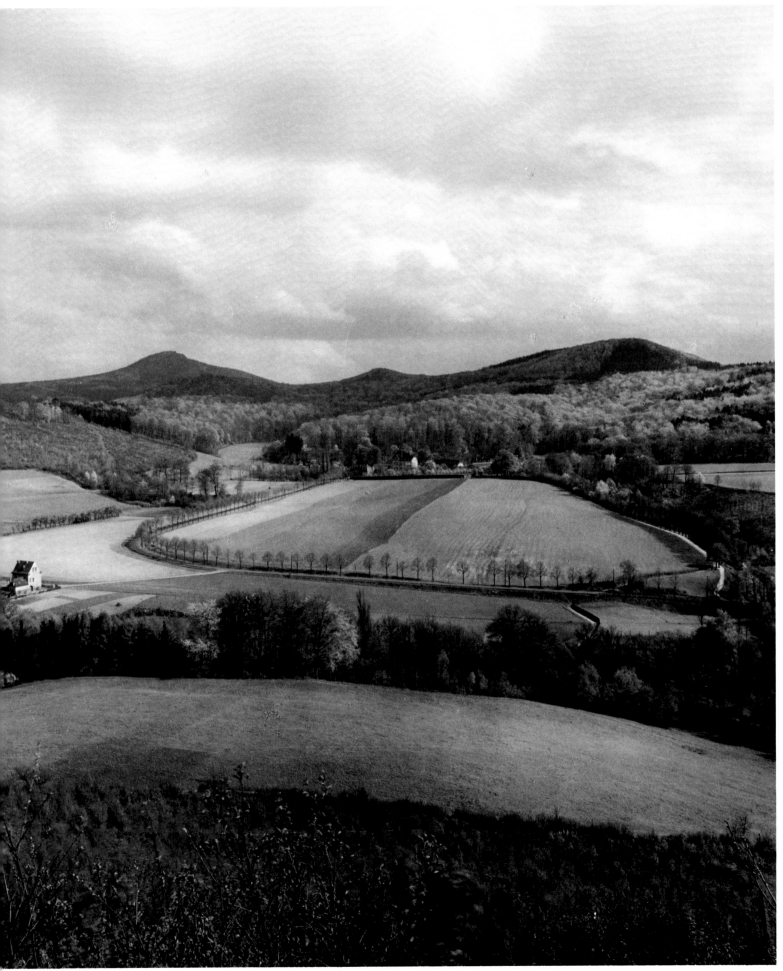

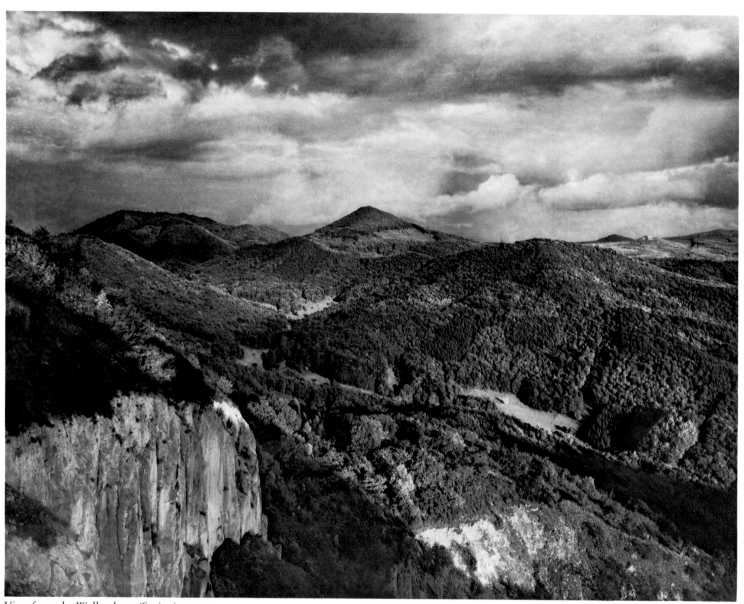

View from the Wolkenburg (Spring) 1937

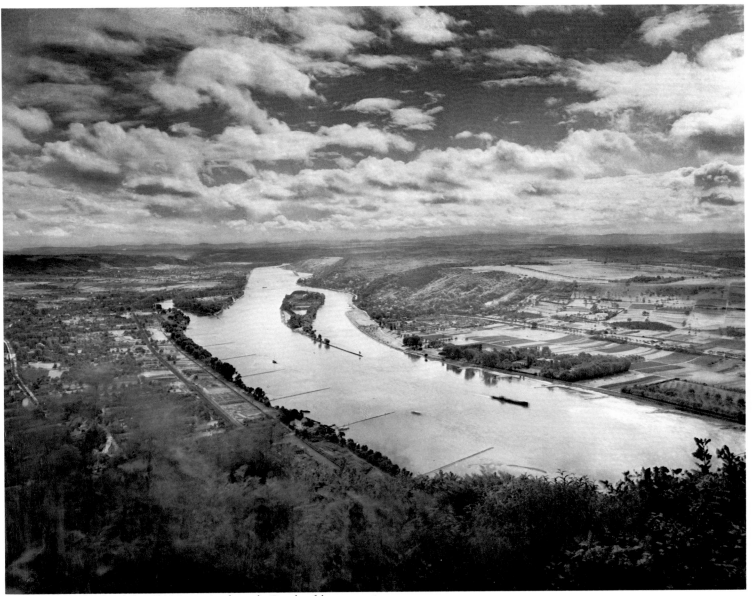

Nonnenwerth Island and the Eifel Mountains from the Drachenfels c. 1936

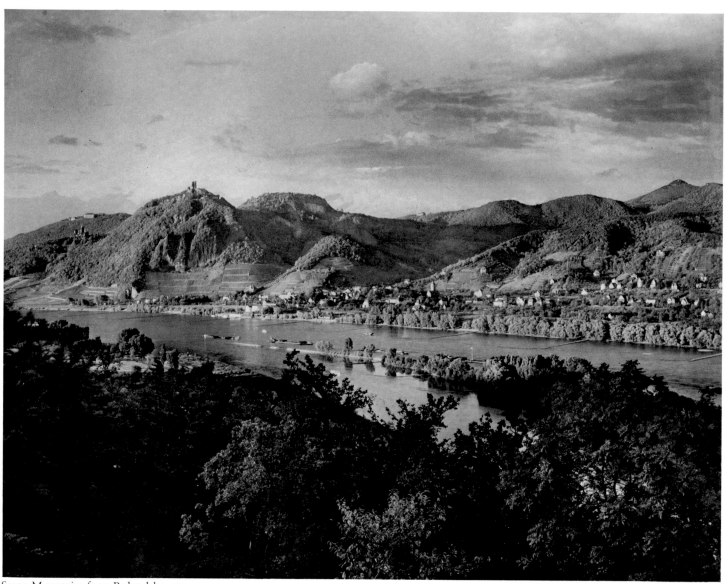

Seven Mountains from Rolandsbogen c. 1937

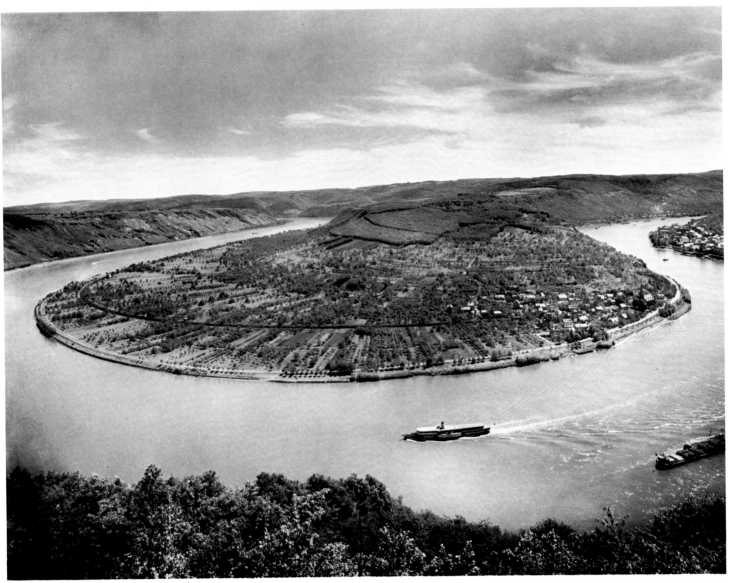

Bend in the Rhine River near Boppard c. 1935

View from the Wolkenburg (Winter) 1940

The Rhine near Dormagen c. 1936

ARCHITECTURE AND INDUSTRY

Man puts his own stamp on the landscape with his works, and the landscape, like language, changes in accord with human needs; man often modifies the results of biological evolution. We can see the human spirit of a particular age expressed in the landscape, and we can comprehend it with the camera. It is the same for architecture and industry and all other large and small works. The landscape within a particular boundary expresses the historic physiognomic image of a nation. If we expand our point of view beyond such boundaries, we can arrive at a comprehensive vision of the nations of the earth in the same way that the observatories arrive at a complete image of their observed heavenly universe. We can arrive at a total vision of the people on earth, a vision that would be of enormous importance to our understanding of humanity.

August Sander, *Photography – a Universal Language*, Lecture 5, 1931

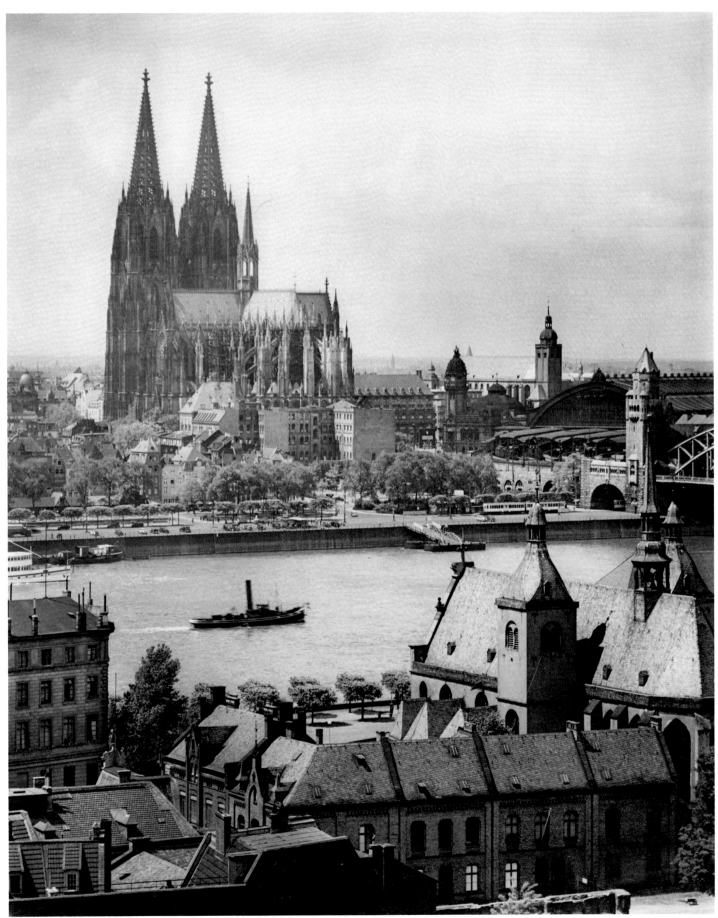

View from Deutz looking toward Cologne Cathedral 1937

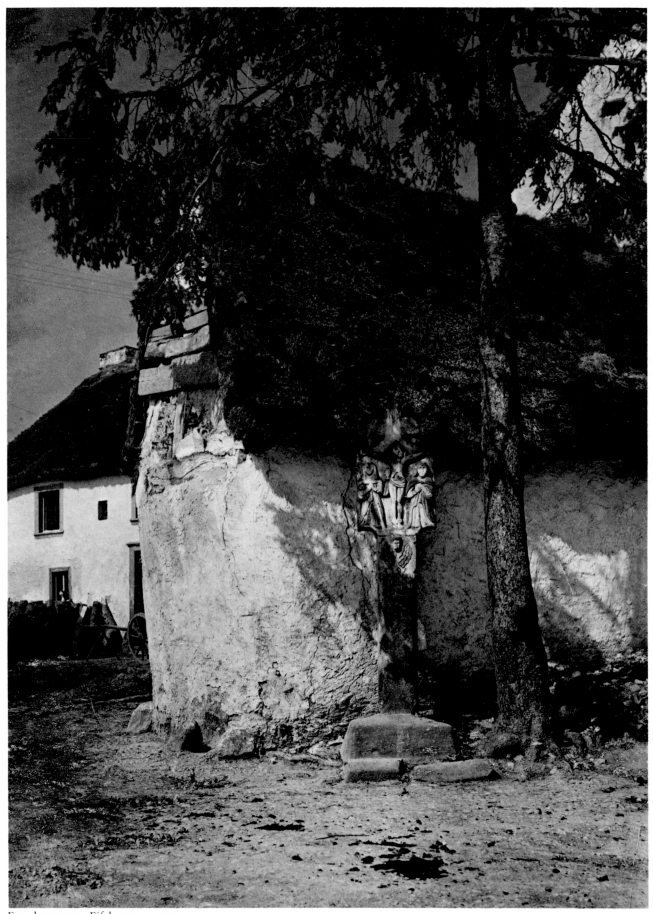

Farmhouse near Eifel area c. 1935

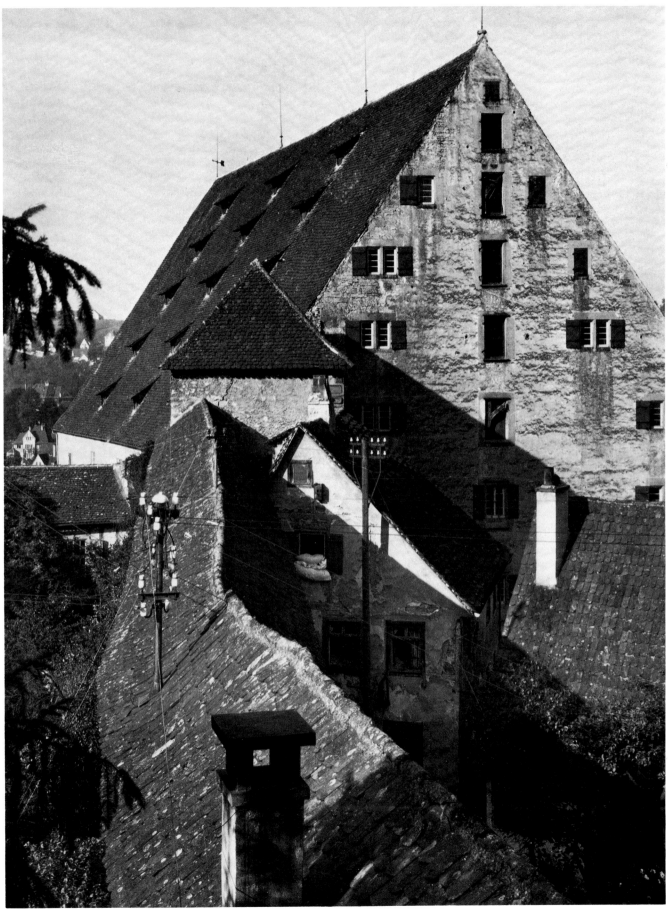

Schwäbisch Halle (festival hall), Southern Germany c. 1933

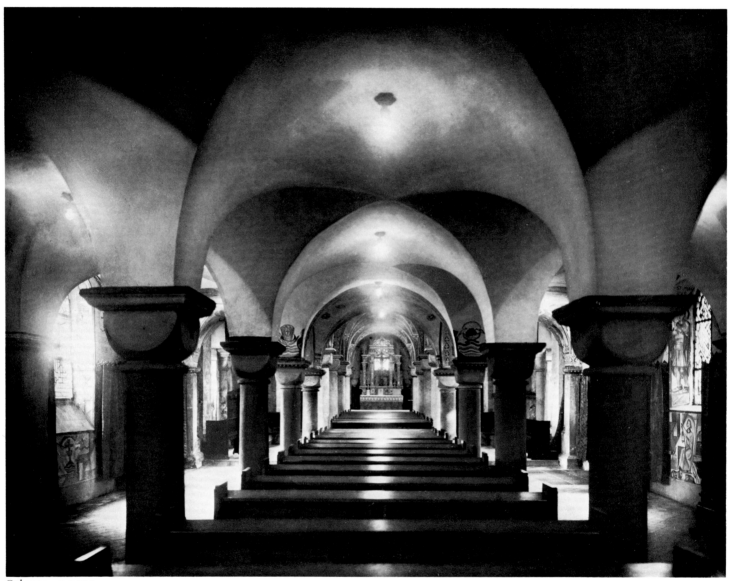

Cologne c. 1932

Cologne c. 1932

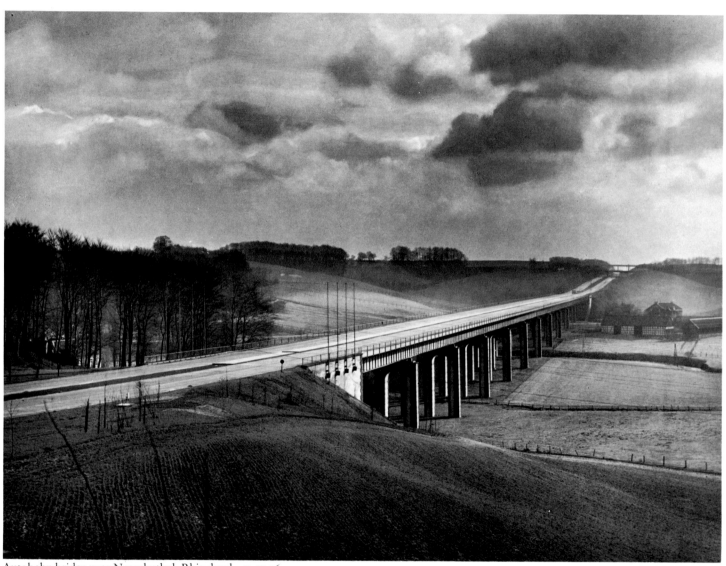

Autobahn bridge near Neanderthal, Rhineland c. 1936

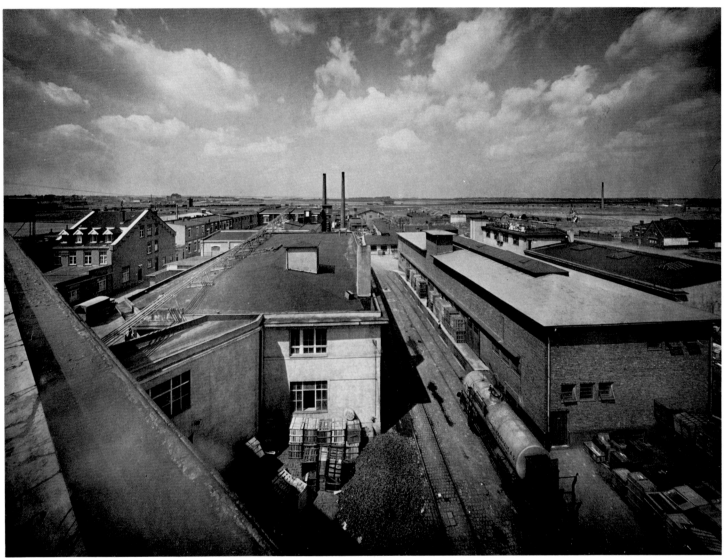

Varnish factory, Cologne 1932

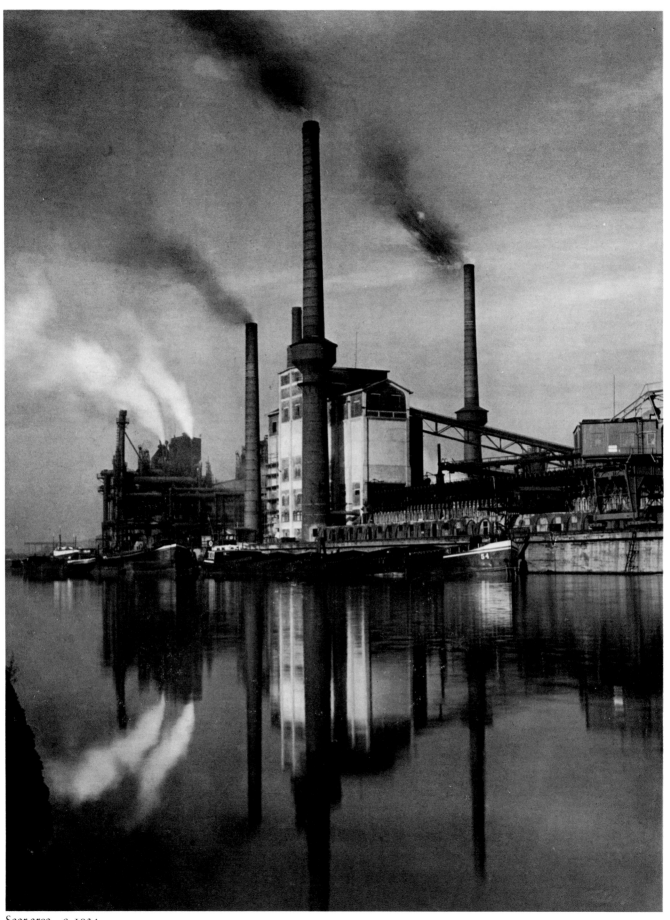

Saar area c. 1934

Schöller Paper Company, Düren c. 1930

NATURE STUDIES

One of my first experiences of the interior of the forest was a strangely colored scene that still lives in my memory like a fairy tale. One beautiful Sunday morning we decided to venture into the forest. The sun, which had awakened us very early, lured us out into the open air, and soon we were striding merrily along. We had selected the oak forest because it was not quite so dark as the fir-tree forest, and above all it did not conceal as many dangers as the thickets of the fir forest. Soon we reached the oak forest and roamed about in it, keeping in constant touch by calling out because we were still afraid, although more and more the sun allayed our fears.

All at once the spring breeze brought a strange, splendid fragrance, and we searched for its source until we suddenly stood before a wondrous pink-blossoming bush. Honeybees, bumblebees, and other insects flew from flower to flower diligently gathering the splendid nectar. We were surprised and delighted at the bush, glistening and gleaming, as it poured out its fragrance in the bright sunlight. It was the first time in my life I had seen it. The bush did not reveal any leaves; only blossoms could be seen in the otherwise gray-green spring forest. In the stillness the regular buzzing of the insects could be heard, and the birds were singing their first songs. Squirrels sprang merrily from branch to branch. The forest no longer seemed as scary and gloomy as it did in the evening.

It was soon time for us to return home. We plucked a bouquet of the beautiful blossoms after we had our fill of gazing at the bush, breathing in its fragrance. We went home, merrily and in high spirits, with the thought of surprising our mother, for we thought that she would certainly not know these flowers. We were disappointed by her look, and we soon learned what we had brought home as she sang a little song:

The daphne that blooms in the woods in spring,
It blooms without leaves, so delicate, pink;
But its fragrance brings danger, though sweet is its breath,
For eating its fruit means certain death.

August Sander, *The Nature and Development of Photography*, Lecture 2, 1931

Plant study c. 1938

Poplar trees, Lower Rhine c. 1935

Footpath in the Seven Mountains c. 1934

Plant study c. 1932

Footpath in the Seven Mountains c. 1934

SARDINIA

The little railway twists along between cactus hedges in countless coils up into the high mountains, then winds in ever-greater loops along a towering mountain chain down again to the river. On the way are picturesque little villages nestled against granite cliffs, defiant castles from the time of the Aragonians, who replaced the Pisan rulers in the Fourteenth Century. On the plain are nuraghi, towering defensive fortresses built in the Bronze Age of huge stone blocks without mortar, which by the thousands defended the highland plains against invaders from the sea.

Cagliari is a quiet, ancient town, whose people are still completely unspoiled by the outside world. Oxen pull the hay wagons with their ancient disk wheels, which certainly had done service at the time of the nuraghi. The house donkey, with blindfolded eyes, trots around the kitchen in a circle and drives the millstone, grinding the rough grain exactly as in primeval times. From Aragonian times there are the low slate-roofed Gothic houses with the entrance halls supported by columns.

It is also worth the effort to make a visit from Cagliari to the innermost part of the island, to the ancient villages of Atzarn and Aritzo, huddled at the foot of snow-covered Mount Gennargentu. A pretty little railway that takes its time gradually carries the traveler through the mountains to the villages where ancient customs and costumes are found in their most original forms and the festivals of the church and the saints are celebrated in the most joyously colorful manner. The costumes are of brilliant colors. The grave Sardinian strides along with pride, dressed in his white linen skirt, his brilliant, richly embroidered jacket, his dazzling white shirt, his black sheep's belt, and his black wool beret. Even more colorful are the peasant women from Aritzo: brown, blue, and red dominate their attire. They are richly adorned with gold chains and buttons, which indicate the status of the woman who wears them.

Ludwig Mathar, 1933

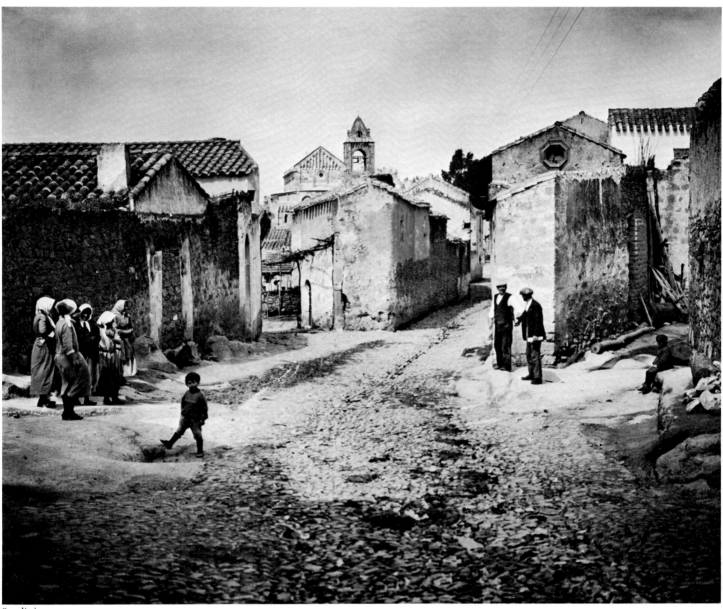

Sardinia 1927

Sardinia 1927

Sardinia 1927

Sardinia 1927

Sardinia 1927

Sardinia 1927

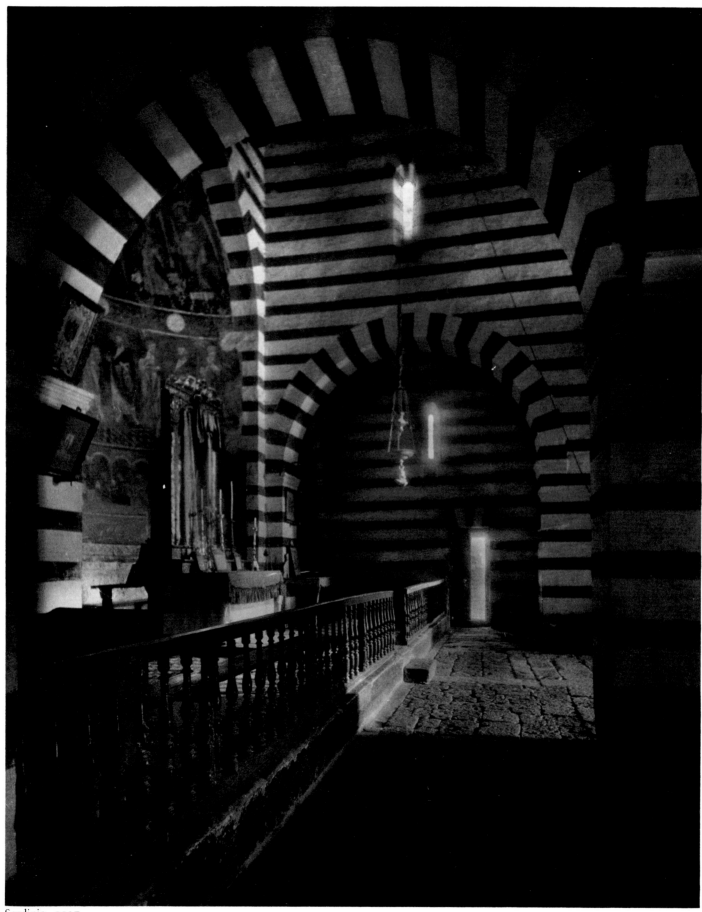

Sardinia 1927

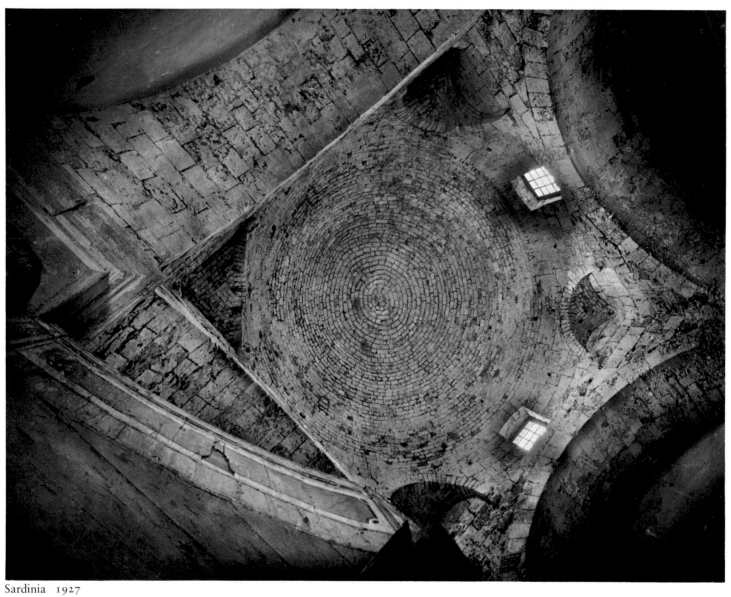

Sardinia 1927

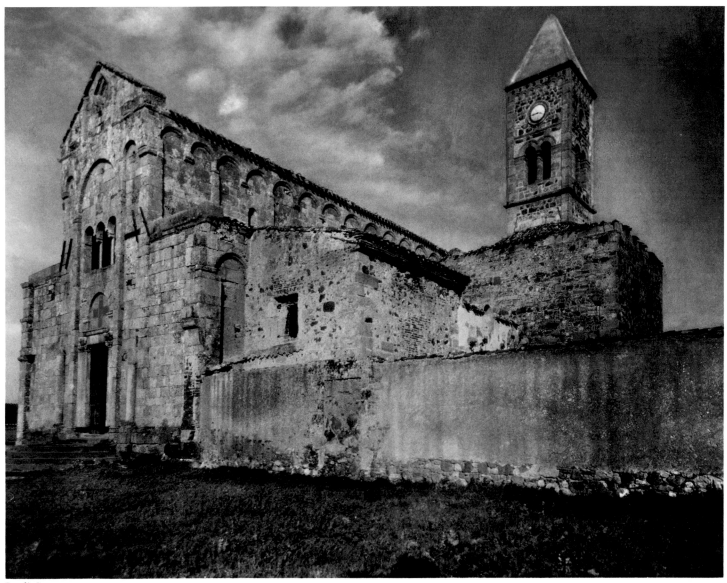

Sardinia 1927

CHRONOLOGY

1876
August Sander born November 17 at Herdorf on the Sieg River, east of Cologne, third son of nine children of mining carpenter August Sander and Rosette Jung Sander.

1882-1888
Attends elementary school in Herdorf. Father teaches children to draw.

1889
Starts apprenticeship as a miner in San Fernando iron mine at Herdorf.

1892
Chance encounter with photographer Friedrich Schmeck of Siegen exposes him to photography. His uncle Daniel Jung buys him a 13 × 18-cm. camera, and his father helps build a darkroom onto the barn. Sander continues to work in the mine, photographing in his spare time.

1896-1897
Performs military service at Trier where he meets future wife, Anna Seitenmacher. Works part time for local photographer Jung (no relation), taking pictures of soldiers.

1898
Sander tours Germany as commercial photographer, taking architectural and industrial pictures. Returns to Trier for six months at Jung's studio.

1901
Is employed by Photographic Studio Greif in Linz, Austria.

1902
Marries Anna Seitenmacher in Trier, then returns to Linz with her. Buys Studio Greif and enters into partnership with Franz Stukenberg for financial reasons, renaming the business Studio Sander and Stukenberg.

1903
First son, Erich, is born December 22. Sander spends most of his time photographing, and wins state medal at arts-and-crafts fair in Linz.

1904
Buys Stukenberg's share in studio, now renamed August Sander Studio for Pictorial Arts of Photography and Painting. Wins gold medal at exhibit in Wels. Succeeds with his first three-color photographs. At Leipzig Book Fair, Sanders wins first prize. Paris Exposition in the Palace of Fine Arts awards him gold medal and Cross of Honor. Seemann, a Leipzig publisher, acquires Sander's color photographs for Leipzig Museum.

1906
First major one-man exhibition at Landhaus Pavillon in Linz includes 100 photographs printed by means of various processes: pigment, bromoil, gravure, and color. Participates in international portrait contest, arranged by Knapp of Halle, and wins fourth prize.

1907
Second son, Gunther, is born November 7. Sander wins honors at the Gevaert contest.

1909
Enters work in the Linz arts-and-crafts exhibition; wins silver medal, highest award. Polio epidemic breaks out in Austria, and Erich is infected. Sander moves family to Trier and sells studio in Linz.

1910
Enters *Newspaper for German Photographers* contest sponsored by the Gevaert Foundation and wins high honors. Moves family to Cologne. Works for four months as manager of Blumberg and Herrmann photographic portrait studio in Cologne, then opens his own studio in Lindenthal, a Cologne suburb. Bicycles every weekend to Westerwald to photograph peasants near the area where he grew up; begins to evolve his life project, "Man of the Twentieth Century."

1911
Twins are born in June; the boy does not survive, but the girl, Sigrid, lives. Sander moves to a larger studio in Lindenthal.

1914
Museum of Arts and Crafts in Berlin selects six photographs for their collection, which also contains photographs by Edward Steichen. Emanuel Bachmann, lecturer in architecture at Cologne Werkschule, hires Sander to photograph architecture for an exhibit sponsored by the Deutscher Werkbund, a design association linking industry and progressive architecture.

1914-1918
Serves in German Army during World War I and continues to photograph. His wife, Anna, manages studio.

1919
Sander photographs Westerwald peasants and Occupation troops from Canada, England, and New Zealand. Begins to teach apprentices and paying students, which continues until mid-1950s.

1921
Meets Franz Wilhelm Seiwert, Progressive painter. Begins friendships with Progressive German artists of the 1920s; stimulating exchanges lead him to clarify his study, "Man of the Twentieth Century." Frequently meets with painters, musicians, and writers: Gottfried Brockmann (who lives with Sander family for two years), Otto Dix, Heinrich Hoerle, Jankel Adler, Anton Räderscheidt, Franz Maria Jansen, Wassily Kandinsky, and others.

1926
Gunther leaves school and becomes Sander's apprentice. His involvement with Cologne Progressives leads him to photograph the annual Artist's Mardi Gras.

1926-1927
Continues "Man of the Twentieth Century," while photographing industrial and architectural subjects, which he continues until World War II. Does advertising work on demand.

1927
Together with author Ludwig Mathar, Sander travels to Sardinia to photograph people and landscapes. Their three-month tour results in excellent photographs, but no agreement is reached with publisher. In December exhibits sixty photographs from "Man of the Twentieth Century" in the Cologne Kunstverein exhibition. Excellent reviews; leads to invitation by editor Kurt Wolff of Transmare publishers to publish complete project in several books, using 500 to 600 photographs.

1929
Face of Our Time published by Transmare; includes introduction by Alfred Döblin. Numerous commissions and exhibitions delay immediate completion of "Man of the Twentieth Century." Works for renowned architects Fritz Breuhaus de Groot, H. H. Lüttgen, and Wilhelm Riphahn.

1930
Exhibits photographs in Hagen and Magdeburg.

1931
Prepares six lectures for West-German Radio (WDR) of Cologne; series titled *Nature and Development of Photography*. Publishes photographs in numerous travelogues. Political turmoil affects Sander, a Social Democrat, and his family. Erich, a leftist, is politically active.

1933
The Nazis come to power. Erich joins opposition. "Sardinia," an article with photographs by Sander and text by Mathar, is published. The first of two books in his series *Deutsche Lande, Deutsche Menschen (German Land, German People), Bergisches Land* and *Die Eifel* with text and photographs by Sander published. Erich, on a photographic trip to the Saar and Paris, is investigated by authorities. Although warned by his family to stay in Paris, he returns to Cologne. Sander assists Erich in reproducing anti-Nazi leaflets photographically after seizure of party press. Erich is arrested.

1934
Three more books in series *German Land, German People* published: *Die Mosel, Das Siebengebirge,* and *Die Saar.* Erich is sentenced to ten years in prison on charges of high treason. Kurt Wolff informs Sander of seizure of his work *Face of Our Time* and destruction of the plates by the Ministry of Culture. Sander's archives are searched repeatedly; valuable negatives are confiscated. Under pressure from the Nazis Sander stops work on "Man of the Twentieth Century."

1935
Begins intensive photographing of the Rhineland and surrounding areas. Photographs landscapes and nature studies on which he works until the end of his life.

c. 1938
Photographs his studio-home in Cologne.

1939-1945
World War II. Sander makes prints of men killed and missing in war for their families. Begins to work again on "Man of the Twentieth Century." Frequent air raids on Cologne destroy his studio; the 40,000 negatives stored in his basement survive. Sander rents part of old farmhouse in Kuchhausen in Westerwald, fifty miles from Cologne.

1944
Moves to Kuchhausen with Anna. Erich dies of ruptured appendix at Siegburg, eight months before the end of his prison term.

1946
Looters set fire in basement of Cologne studio destroying 40,000 negatives. For his seventieth birthday, West-German Radio in Cologne interviews Sander.

1949
After remodeling Kuchhausen studio, begins to photograph people and landscapes and to work on special projects: *Flora of the Rhine; The City of Cologne As It Was; Rhineland Architecture from the Time of Goethe to Our Day; Organic and Inorganic Tools of Man; Cologne Painters of Today: Types and Reproductions of their Work 1920 – 1933; Man and Landscape; The Studio of a Photographer of the Twentieth Century* (to include his own writings on photography).

1951
L. Fritz Gruber, director of Photokina, invites Sander to show his work at its first exhibition, which is also the first extensive international photographic exhibition to be held after World War II. Sander reprints old negatives and makes new images to complete "Man of the Twentieth Century."

1952
Edward Steichen, director of photography at The Museum of Modern Art in New York, visits Sander in Kuchhausen at Gruber's suggestion to select photographs for his "Family of Man" exhibition, returning with approximately forty-five works.

1953
The Museum of Modern Art accepts a gift of approximately seventy works by Sander. The Cologne Museum purchases "Cologne As It Was," a collection of architectural photographs made before the destruction of the city during World War II.

1955
"The Family of Man" exhibition at The Museum of Modern Art in New York contains three works by Sander, which also appear in the accompanying publication.

1957
Anna, after fifty-five years of marriage to Sander, dies.

1958
Honored by an exhibition in his hometown of Herdorf and made honorary citizen. Tapes a radio broadcast for Southwest Radio in Mainz. Also named honorary member of German Photographic Society.

1959
German Photographic Society mounts exhibition in Cologne, "August Sander, Figures of His Time." Manuel Gasser, editor of Swiss magazine *du*, visits Kuchhausen to plan special November edition dedicated to Sander.

1960
Receives Order of Merit of the Federal Republic of Germany.

1961
Receives Cultural Prize of the German Photographic Society; exhibits at the Free University of Berlin and in Mexico.

1962
Deutschenspiegel (Mirror of Germans), with an introduction by Heinrich Lützeler, is published.

1963
John Szarkowski, who succeeds Edward Steichen as director of photography at The Museum of Modern Art, writes a cover story, "August Sander, the Portrait as Prototype," for June issue of *Infinity*. In December, Sander suffers a stroke and is admitted to a Cologne hospital.

1964
August Sander dies in Cologne at the age of eighty-eight.

BIBLIOGRAPHY

BOOKS

Amman, Jost, and Sachs, Hans. *Ständebuch (The Book of Trades)*. Introduction by Benjamin A. Rifkin. New York: Dover, 1973.

August Sander. Preface by John von Hartz. Millerton, N.Y.: Aperture, 1977.

Barthes, Roland. *Image – Music – Text*. New York: Hill and Wang, 1977.

Benjamin, Walter. *Illuminations*. New York: Harcourt, Brace and World, 1968.

Bertonati, Emilio. *Die neue Sachlichkeit in Deutschland (The New Objectivity in Germany)*. Munich: Schuler, 1974.

Börsch-Supan, Helmut. *Caspar David Friedrich*. New York: Braziller, 1974.

Brion, Marcel. *German Painting*. New York: Universe Books, 1959.

Brophy, John. *The Human Face*. Englewood Cliffs, N.J.: Prentice-Hall, 1946.

Dahrendorf, Ralf. *Society and Democracy in Germany*. Garden City, N.Y.: Doubleday, 1967.

Deutschland Erwacht: Werden, Kampf und Sieg der NSDAP (Germany Awakens: Development, Struggle and Victory of the National Socialist Party). Altona-Bahrenfeld: Zigarettenbilderdienst, 1933.

Doede, Werner. *"Berlin," Kunst und Künstlerseit 1870 ("Berlin," Art and Artists since 1870)*. Recklinghausen: Aurel Bongers, 1961.

Eckardt, Wolf von, and Gilman, Sander L. *Bertold Brecht's Berlin*. Garden City, N.Y.: Doubleday, 1975.

Eyck, Erich. *A History of the Weimar Republic*. New York: Atheneum, 1962.

Finke, Ulrich. *German Painting*. Boulder, Colo.: Westview Press, 1975.

Fosbroke, Gerald Elton. *Character Reading*. Garden City, N.Y.: Garden City Publishing Co., 1938.

Friedenthal, Richard. *Goethe*. Cleveland and New York: World Publishing Co., 1963.

Gasser, Manuel, ed. *du* magazine special edition on August Sander with fifty portrait photographs. Zürich, Switzerland: Conzett and Huber, November 1959.

Gay, Peter. *Weimar Culture*. New York: Harper & Row, 1968.

Goethe, Johann Wolfgang. *Faust*. Transl. by Walter Kaufmann. Garden City, New York: Doubleday, 1961.

Grillparzer, Franz. *Vom Geist der Kunst. (On the Spirit of Art)*. Munich: Albert Langen/ Georg Müller, 1941.

Grosz, George. *Ecce Homo*. Introduction by Lee Rewens. New York: Brussel and Brussel, 1965.

——. *Love above All, and Other Drawings*. New York: Dover, 1971.

Gruber, L. Fritz., ed. *Grosse Photographen unseres Jahrhunderts. (Great Photographers of Our Century)*. Düsseldorf/Vienna: Econ, 1964.

Hertel, Bernhard. *Die Bildwerke des Kölner Domes. (Statuary of Cologne Cathedral)*. Berlin: Deutscher Kunstverlag, 1923.

Hinz, Berthold. *Art in the Third Reich*. New York: Pantheon Books, 1979.

Hoffmann, Heinrich. *Adolf Hitler, Bilder aus dem Leben des Führers (Pictures from the Life of the Führer)*. Preface by Joseph Goebbels; essays by Rudolf Hess, Albert Speer, et al. Altona Bahrenfeld: Zigarettenbilder, 1936.

Holbein, Hans, the younger. *The Dance of Death.* Introduction by Werner L. Gundersheimer. New York: Dover, 1971.

Hölderlin, Friedrich. *Werke (Works).* Tübingen: Rainer Wunderlich, n.d.

Kinser, Bill, and Kleinmann, Neil. *The Dream That Was No More a Dream, 1890-1945.* New York: Harper & Row, 1969.

Lieberman, William S. *Art of the Twenties.* New York: The Museum of Modern Art, 1979.

Ligget, John. *The Human Face.* New York: Stein and Day, 1974.

Lindemann, Gottfried. *History of German Art.* New York: Prager, 1971.

Mantegazza, Paolo. *Physiognomy and Expression.* London: Walter Scott. n.d.

Nietzsche, Friedrich. *The Portable Nietzsche.* Ed. and transl. by Walter Kaufmann. New York: Viking, 1954.

Paul, Jean (pseud. for Jean-Paul Friedrich Richter) *Jean-Paul Werk — Leben — Wirkung (Jean-Paul, Works — Life — Influence).* Munich: Piper, 1963.

Pollack, Peter. *The Picture History of Photography from the Earliest Beginnings to the Present Day.* New York: Harry N. Abrams, 1962. German edition, Vienna and Düsseldorf: Econ, 1962.

Reinhardt, Kurt F. *Germany: 2,000 Years,* Vol. II. New York: Ungar, 1962.

Ringer, Fritz K. *The Decline of the German Mandarins.* Cambridge, Mass.: Harvard University Press, 1969.

Roethel, Hans Konrad. *Modern German Painting.* New York: Reynal and Company., n.d.

Roh, Franz. *German Painting in the 20th Century.* Greenwich, Conn.: New York Graphic Society, 1968.

Roh, Franz, and Tschichold, Jan, eds. *Foto-Auge.* 76 Photographs of the Period. Tübingen: Ernst Wasmuth, 1929. Reprinted 1973.

Sander, August. *Antlitz der Zeit (Face of Our Time).* Introduction by Alfred Döblin. Munich/Berlin: Transmare, 1929. Reprinted, Munich: Schirmer Mosel, 1976.

——. *Bergisches Land: Deutsche Lande, Deutsche Menschen (German Land, German People).* Düsseldorf: Schwann, 1933.

——. *Das Siebengebirge: Deutsches Land, Deutsches Volk (German Land, German People)* Rothenfelde: Holzwarth, 1934.

——. *Deutschenspiegel (Mirror of Germans).* Introduction by Heinrich Lützeler. Gütersloh: Sigbert Mohn, 1962.

——. *Die Eifel: Deutsche Lande, Deutsche Menschen (German Land, German People).* Düsseldorf: Schwann, 1933.

——. *Die Mosel: Deutsches Land, Deutsches Volk (German Lands, German People).* Rothenfeld: Holzwarth, 1934.

——. *Menschen ohne Maske. (Men without Masks).* Text by Gunther Sander, foreword by Golo Mann. Lucerne/Frankfurt am Main: C. J. Bucher, 1971. English edition, Greenwich, Conn.: New York Graphic Society, 1973.

——. *Rheinlandschaften (Rhineland Landscapes).* Text by Wolfgang Kemp. Munich: Schirmer Mosel, 1975.

——. *Unsere Heimat Hannover (Our Homeland, Hannover).* Mönchen-Galdbach: Volksverein, 1924.

Schultze, Jürgen. *Art of 19th Century Europe.* New York: Abrams, n.d.

Von Dadamax zum Grüngürtel — Köln in den 20er Jahren. (From Dadamax to the Green Belt — Cologne in the Twenties). Catalogue for exhibition. Cologne: Kölnischer Kunstverein, 1975.

Werner, Alfred, ed. *293 Renaissance Woodcuts for Artists and Illustrators.* New York: Dover, 1968.

Willet, John. *Art and Politics in the Weimar Period.* New York: Pantheon Books, 1979.

ARTICLES AND OTHER WORKS

André, Michael. "Surveying a Modern Nation State." Concerning exhibit at Robert Schoelkopf Gallery, New York. *Photography,* December 1975.

"Antlitz der Zeit., 60 Photographien deutscher Menschen. Ein Werk des Kölner Photographen August Sander" ("Face of Our Time. Sixty Photographs of Germans. A Work by the Cologne Photographer August Sander"). Review. *Rheinische Zeitung,* December 10, 1930.

"Antlitz der Zeit" ("Face of Our Time"). Review of Sander's work. *Der Türmer, Deutsche Monatshefte, Heinrich Beenken,* Berlin, October 1930.

"Antlitz der Zeit." Previews. Kurt Wolff/Transmare, Munich, 1929.

"Antlitz der Zeit." *Pester Lloyd,* Budapest, c. 1929.

"Antlitz der Zeit." Review. *Nationalzeitung,* Basel, Switzerland. n.d.

"August Sander-Ausstellung gut besucht" ("August Sander Exhibit Had Many Visitors"). Review of 1958 events at Herdorf. *Westfälische Rundschau,* Dortmund, October 5, 1958.

"August Sander — Herdorfs neuer Ehrenbürger" ("August Sander — Herdorf's New Honorary Citizen"). *Rhein-Zeitung,* Koblenz, April 26, 1958.

"August Sander kommt nach Herdorf . . ."

("August Sander Will Come to Herdorf . . ."). Events at 1958 Herdorf exhibit. *Westfälische Rundschau,* Dortmund, April 25, 1958.

"August Sander zum 60. Geburtstag" ("August Sander on his Sixtieth Birthday"). *Kölnische Zeitung Stadt-Anzeiger,* Cologne, November 17, 1936.

Belling, Paulus. *"August Sander zum Gedenken"* ("In Memory of August Sander"). *Fotoprisma IX,* September 1964.

Benjamin, Walter. *"Kleine Geschichte der Photographie"* ("Brief History of Photography"). *Die Literarische Welt,* Berlin, October 2, 1931.

Bohnen, Uli. *"August Sander, der Fotograf,"* excerpt from *"Die Gruppe progressiver Künstler im Rheinland 1918-1933"* ("The Progressive Artists Group in the Rhineland 1918-1933"). Dissertation. Aachen: 1974.

Bourfeind, Paul. *"Menschen des 20. Jahrhunderts"* ("Man of the Twentieth Century"). Essay. *Rheinische Blätter für Kulturpolitik,* January 1928.

Eggebrecht, Axel. *"Zu einem Fotobuch"* ("Concerning a Book of Photographs"). Review of *Face of Our Time. Die Literarische Welt,* March 14, 1930.

"Ein Ereignis — Herdorf selbst zur Ehre" ("An Event — Herdorf Honors Itself"). Review of 1958 Herdorf exhibit. *Westfälische Rundschau,* Dortmund, May 10, 1958.

Eisner, Paul. *"Gesichter"* ("Faces"). Review of *Face of Our Time. Prager Presse,* Prague, January 26, 1930.

Goldman, Judith. "Sander Hunted for Archetypes in the Weimar Republic." Review of exhibit at Robert Schoelkopf Gallery, New York, 1975. *Village Voice,* October 20, 1975.

Halley, Anne. "August Sander." Includes transl. of Sander's "Photography — a Universal Language," Lecture 5 of *The Nature and Development of Photography* for West-German Radio, 1931. *The Massachusetts Review,* University of Massachusetts, Amherst, Mass., Winter 1978.

Hoffmann, Josef. *"Sohn der Väter und der Heimat"* ("Son of His Fathers and of His Homeland"). Reading at Herdorf, exhibit 1958. Unpublished. Excerpts, *Westfälische Rundschau,* Dortmund, May 10, 1959.

——. *"Vom Hauer zum Vater der Fotografie"* ("From Miner to Father of Photography"). *Westfälische Rundschau,* Dortmund, May 3, 1958.

H.S. *"Im Mechernicher Bleiberg"* ("In the Lead Mine of Mechernich"). *Stadt-Anzeiger für Köln und Umgebung,* late ed., Cologne, July 24, 1933.

Jüttner, Werner. "August Sander." Notes and chronology for exhibition "August Sander —

Figures of His Time" at Deutsche Gesellschaft für Photographie, Cologne, 1959.

Kahmen, Volker. *"August Sander, Mensch und Landschaft"* ("Man and Landscape"). Notes for exhibits at Bahnhof Rolandseck, Cologne, 1970, 1977, 1978.

"Kölner Brief" ("Letter from Cologne"). *Generalanzeiger für Dortmund,* December 16, 1927.

"Kunstnachrichten" ("Art News"). Review of 1927 exhibit at Cologne Kunstverein. *Der Nachrichtendienst,* December 17, 1928.

"Landschaft als Negativ" ("Landscape as Negative"). *Freitag Abendblatt,* Cologne, February 2, 1934.

L.W. *"Der Mensch und das Tier"* ("Man and Animals"). *Dienstag Abendblatt,* Cologne, December 5, 1933.

Mann, Thomas. Letter concerning *Face of Our Time.* January 6, 1930.

Mathar, Ludwig. *"Sardinien"* ("Sardinia"). *Stadt-Anzeiger für Köln und Umgebung,* Cologne, September 7, 1933.

Maus, Toni. Tape on life and work of August Sander, made at closing of 1958 Herdorf exhibit for Southwest Radio, Mainz. At Heimatarchiv, Herdorf.

Mente, O. *"Neue Aufgaben für die Photographie"* ("New Tasks for Photography"). *Das Atelier des Photographen,* February 1928.

Neugass, Fritz. *"Ein Hund wurde zum Tausendfüssler"* ("A Dog Became a Centipede"). Review of 1975 exhibit at Robert Schoelkopf Gallery, et al., in New York. *Frankfurter Allgemeine Zeitung,* Frankfurt, November 11, 1975.

Panter, Peter (pseud. for Kurt Tucholsky). *"Auf dem Nachttisch"* ("On the Night Table"). *Die Weltbühne,* Berlin-Charlottenburg, March 25, 1930.

Pommer, Richard. "August Sander and the Cologne Progressives." *Art in America,* January-February 1976.

Reedijk, Hein. Catalogue for 1974 Konfrontatie 2 exhibit "August Sander and Willem Diepraam, Photographers," Eindhoven, Netherlands: Van Abbemuseum, 1974.

Rosenfeld, Fritz. *"Das Antlitz der Zeit"* ("Face of Our Time"). *Salzburger Wacht,* Salzburg, December 6, 1929.

Sander, August. *Das Wesen und Werden der Photographie. (The Nature and Development of Photography):* 1. "From the Alchemist's Workshop to Exact Photography"; 2. "The Nature and Development of Photography from Past to Future (from the Experiment to Practical Use)"; 3. "The Nature and Development of Photography from Past to Future (Photography at the Turn of the Century)"; 4. "Photogra-phy in Science and Technology"; 5. "Photography — a Universal Language" (see Halley, Anne); 6. "Today's Photographic Practice." Series of lectures. West-German Radio, Cologne, 1931.

——. *"Haubergswirtschaft im Siegerland"* ("Hilltop Farming in Siegerland"). *Stadt-Anzeiger für Köln und Umgebung,* Cologne, April 23, 1933.

——. *"Wildgemüse"* ("Wild Plants"). *Velhagen und Klasings Monatshefte,* Berlin, June 1937.

Sander, Christine. *"August Sander 1876-1976."* Catalogue for 1976 exhibition. Sander Gallery, Washington, D.C., 1976.

Sander, Gunther, and Dieuzaide, Jean. Goethe Institute Catalogue for 1979 exhibition "August Sander," at Galerie Municipale du Château d'Eau, Toulouse.

Seufert, Heinrich. *"Antlitz der Zeit oder Triumph der Photographie"* ("Face of Our Time, or the Triumph of Photography"). Review of Sander's work. *Nürnberger Zeitung,* Nürnberg, February 26, 1930.

Szarkowski, John. "August Sander, the Portrait as Prototype." *Infinity,* June 1963.

Thornton, Gene. "A Great Portraitist Feared by the Nazis." Review of exhibit at Robert Schoelkopf Gallery, New York, 1975. *The New York Times,* September 28, 1975.

Radio Free Berlin. Television interviews with Gunther Sander et al. about August Sander. January 21, 1976.

Viebig, Clara. *"Gesichter aus einer deutschen Landschaft"* ("Faces of a German Landscape"). Review. February 1931.

Walther, Mayor of Herdorf. Address making August Sander honorary citizen. Herdorf, April 30, 1958.

Winterberg, Hans, and Stratta, Alberto. Catalogue for 1977-78 Turin, Italy exhibition "August Sander Fotografia Sociale 1906-1952" containing introduction by Piero Racanicchi, 1929 article by Alfred Döblin, and 1959 article by Golo Mann. Goethe Institute, Turin, 1977.

The chronology and bibliography for this publication were prepared by Almut Fitzgerald of Goethe House in New York and expanded from previous research by Gunther Sander and The Goethe Institute in Turin. Additional information was provided by: Gerd Sander, Washington, D.C.; Susan Kismaric and Grace Mayer, The Museum of Modern Art; Robert Kramer, Manhattan College, Riverdale, New York; German Information Center, New York; Susan Macy, American Society of Magazine Photographers; Lee Sievan, International Center of Photography; and Jane Schoelkopf, Robert Schoelkopf Gallery, New York.

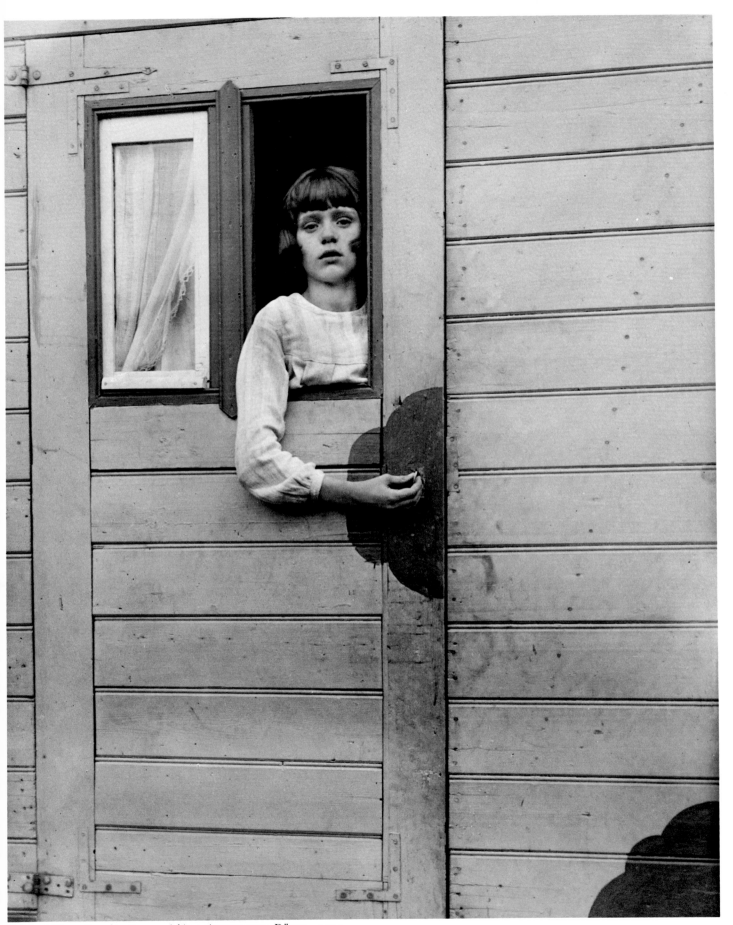

Fair and Circus People Young girl in a circus wagon, Düren 1932

Aperture, Inc., a public foundation, publishes a periodical, portfolios, and books to communicate with serious photographers and creative people everywhere. A complete catalogue of Aperture publications will be mailed free upon request. The address is: Aperture, Inc., Millerton, New York 12546.

August Sander: Photographs of an Epoch is supported by a grant from the National Endowment for the Arts, Washington, D.C., a federal agency.

Design by Robert Aulicino and Wendy Byrne.
Printed by Rapoport Printing Corporation, New York City.
Bound by Sendor Bindery, New York City.
Manufactured in the United States of America.

Aperture books are distributed exclusively: in Canada, by Van Nostrand Reinhold Ltd., Toronto, Ontario; in Italy, by Idea Books, Milan; in all other major world markets excepting the Americas and Japan by Phaidon Press Ltd., Oxford, England.